WRITING THE ARTIST STATEMENT

REVEALING THE TRUE SPIRIT OF YOUR WORK

BY

ARIANE GOODWIN

INFINITY PUBLISHING

Cover design: Asa Muir-Harmony
Back Cover photo: Lilia Teal
Book design: A. Goodwin, Ed.D.

ISBN 0-7414-0843-0

Published by:

1094 *New DeHaven Street, Suite 100*
West Conshohocken, PA 19428-2713
Info@buybooksontheweb.com
www.buybooksontheweb.com
Toll-free (877) BUY BOOK
Local Phone (610) 941-9999
Fax (610) 941-9959

Printed in the United States of America
Printed on Recycled Paper
Published February 2007

For my artist mother,

MARGARET,

*who swept large brush strokes of shimmering color
over all of our lives*

CONTENTS

ACKNOWLEDGMENTS

My deepest gratitude goes to:
- All of my extraordinary workshop participants who offered their insights with such open hearts and singing minds.
- Lydia Grey and Asa Muir-Harmony, whose artistic sensibilities have nourished my spirit and this book: Lydia, with her wondrous clay vessels and words, and Asa with her cover design.
- Robert Able, Cheryl Rezendes, and Paul Langman, whose sharp eyes and keen wits kept my manuscript honest.
- Ayr Muir-Harmony, whose timely—and savvy—technology generosity saved the day.
- Rebecca & Michael Muir-Harmony and Judy Phillips, who have kept the faith in me over many years.
- My daughters, Lilia and Serena, who shelter my heart and keep me sane.

IN THIS BOOK, THERE ARE THREE PATHS.

The WHOLE TRACK—from beginning to end—is a developmental sequence of information and exercises designed to ease you into writing an artist statement. The journey integrates the technical and professional levels of writing with an emotional and spiritual understanding of why you are doing this.

The FAST TRACK—the technical nuts and bolts on how to write an artist statement—can be pulled together from chapters: 2, 5, 7, 9, 12, 24, 27, 28-39, and 41-44.

The CONTEMPLATIVE TRACK—a tapestry of psychological, philosophical, and spiritual information, which relates to a range of professional and personal pursuits besides the artist statement—can be found in chapters 1, 3, 4, 6, 8, 11, 13-23, 26, 30 and 46.

Revealing *what*, *how* and *why* you do your art does not dismantle either the beauty or mystery of it. Quite the opposite. Your effort to reach out invites others to participate in the mystery and to share the beauty.

—*ARIANE*

WARMING UP
IN THREE PARTS:

WHAT IS AN ARTIST STATEMENT

WHY WRITE AN ARTIST STATEMENT

WHO USES AN ARTIST STATEMENT

PART ONE

WHAT IS AN ARTIST STATEMENT

MAKING THE NEGATIVE POSITIVE

Contrary to popular belief—that we should start with the positive and work sideways into the negative, which of course we shouldn't even call negative but something bewilderingly positive like challenging—I find starting with the negative invigorating. It's like weeding a garden. You yank up what you don't want, and lo and behold there is enough room for what you do want.

One of the greatest frustrations about an artist statement is deciding what, exactly, it is. To some extent, it depends on who you are. To a gallery owner it might be a good public relations tool. To an art agent, it might be a point-of-purchase tool. To an art patron, it might be the beginning of a collection. But, right now, it is critically important that it be none of these things for you, the artist. An artist needs and deserves uncluttered space for the artist statement to flourish. To that end, we are going to yank up all of the things that an artist statement, to the artist, *is not*.

Your part is to exercise your fertile, artistic imagination and create a convincing world for yourself where there are no galleries, no art dealers, no collectors, no critics. *Right now, right here, there is only you, your art and the bridge of personal power between the two.*

In this real world of your imagination, the starting point is trust: trusting that these three elements are all you actually need.

If you find this difficult or implausible, then let's revive an old, reliable learning tool you will remember best as, *let's pretend!*

For the remainder of this book, actively suspend your self-criticism and doubt and *pretend* that you, your art, and your relationship to your art, in this moment, are completely *enough*...as indeed, they are.

WHAT AN ARTIST STATEMENT IS *NOT*

An artist statement is not a resume. A resume is a list, by date, of all the pertinent, professional events in your art life, including your education, which would help convince people that you are a "serious" artist, worth collecting. Events are selected to give the impression that your art life has been important, therefore you are important. A resume is informative, impersonal, and dry. It is utilitarian, not inventive. It does not illuminate your work; it relegates your work to a file folder. An artist statement is not a resume.

An artist statement is not a biographical summary of your work. A biographical summary chronicles the events in your personal life that intersect with your art life. When did you begin your art? How has your artwork influenced different events in your life? What, and who, orbits around your art world? A biographical summary is more colorful than a resume, if in fact your life is colorful. It is not a list like a resume, but a few paragraphs of prose. An artist statement is also prose and may include relevant biographical tidbits, but it is not, in its entirety, a biographical summary.

An artist statement is not a critique. A critique is an evaluation of your artwork that places a judgment on it, or identifies where it fits into the art scene. A critique is about likes and dislikes, comparisons and labels. It is judgmental, opinionated, and well ... critical. It distinctly reflects the "opinions" of others as opposed to the "reflections" of the artist. An artist statement is not a critique.

An artist statement is not a list of accomplishments. A list of accomplishments is just that: what have you accomplished in the art world, of note, that you would like to crow about? What awards, collections and exhibitions have you snagged? Like the resume, it is an informative, impersonal list. In fact, it is almost interchangeable with a resume. Even though an accomplishment might, organically, find its way into your statement, an artist statement is not simply a list of accomplishments,

Have we pulled enough weeds?

Is there enough room in this garden to grow a few artist statements?

Almost ... just one more really tough yank!

An artist statement is not a marketing tool!

SOUL: NOT FOR SALE!

Our twenty-first-century culture is indisputably a culture of, by, and for competition. And nowhere is this more apparent than in the scarcity myth we are sold: too many artists, *they* holler, with too few outlets for art! Scarcity is good, *they* hammer. It will drive up the price of our art. Driving up the price of art is good too. This ensures our fame and fortune. (What more could we possibly want? *They* raise an eyebrow.)

The population of artists, counted in North America alone, is estimated at 250,000 and rising. From the panic of a poverty perspective, labeling everything as having potential for marketing, or "making it," becomes seductive, if not downright sexy. No small wonder that, under this cloud of scarcity, the artist statement is consistently mislabeled as a marketing tool. PR articles hawk titles such as "The Artist Statement: Your Secret Weapon," which keep the competition wheels of fear well-greased, reinforce that artists are under siege, and suggest that we should prepare for the worst.

Besides being inaccurate, calling an artist statement a "marketing tool" is counterproductive. It puts a very big cart before a very small horse. In the name of the "market," it actually brings little hope of making it to market before all the vendors have dismantled their wares and gone home.

The confusion is understandable. An artist statement, after all, can be, and is, used as a marketing tool; *but,* that is not what it is. The distinction is critical. Once you know what something is (e.g., horse) you can figure out how to use it (e.g., attach to cart), and off to market you go.

If, however, you define an artist statement by its functions, it would be like saying the horse (artist statement) is the cart (marketing). This runs the very real risk of missing altogether the true essence of an artist statement, thereby diminishing its potential for effectiveness.

The point of an artist statement is to be in service to your art, not the marketplace. Identifying an artist statement as something immediately and primarily for marketing—*Do not pass go! Do not collect artistic integrity!*—diminishes the spirit behind your work. Like art which is created with the pocketbook in mind, artist statements that focus on the shallow "point of purchase" technique lose their authenticity, their authorship, and their unique reflections.

Marketing strategies, by their very nature, are designed to be manipulative, while the power of an artist statement lies in the authenticity of its authorship. When you define an artist statement as a marketing ploy, it effectively undermines the sincerity needed for a convincing, compelling statement. We humans instinctively know when something is done with care or not. There is a resonance of the *cared for* that is unmistakable. We may not be able to say exactly why, or what, we are responding to, but when something is done with respect to authenticity and the spirit, respond we do.

Perhaps we respond because the authentic and cared for sings out to us. If it is computer clip art, it sings about *fast* and *easy* and *automated*. It sings: "machine speaking!" But if it is computer art that has been cared about, it sings: *machine in service to art speaking*.

We can fool our minds a lot of the time, we can fool our bodies some of the time, but we can never fool our inner knowing. (We can only ignore, dismiss, or try to bury it.) A current of life energy that flows through our behavior ignites everything we do or say, including our artist statement. This current of life energy carries a specific quality of care that, quite simply, either draws people closer to our art, or pushes them away.

It is true that your artist statement may end up being *used* as a marketing tool—only *one* of several possible applications—but that is not *what it is*. This distinction is important. Key, in fact, because writing is hard enough without artists imagining that they have to satisfy the elusive and enigmatic "market." Better, and far more practical, to start with what is familiar and closer to home: *the uniqueness of your work,* for herein lies the power of an artist statement.

Like the art that it reflects, an artist statement uses its sincerity of purpose and its purity of intent to create a powerful *word-reflection* of the art and the artist. Once that has been accomplished, and only then, will your artist statement have a fighting chance of becoming an effective marketing tool.

So, no, you don't have to sell your soul. What the artist statement asks is that you *reveal* your soul. Revealing the true spirit of your work, in the end, is what pulls the cart straight into the hearts of the people who are your market.

CHEERLEADING REVISITED

If you were like me in high school, cheerleading was definitely out. Immature wind-up dolls, who smiled on cue and bubbled over with a week's worth of good will, were way too cheerful to be taken seriously.

In the years since then, I've realized that cheerleading is an underrated skill and far from superficial. In my naive, intellectual elitism, not to mention my superior, adolescent cynicism, I misjudged the true nature of cheerleading from the scanty clothes it wore and the color of its nail polish—that it even *wore* nail polish. With my nose in the air, I missed quite a few things.

Cheerleading is inarguably about enthusiasm, conviction, contagion ... and the moxie to show it. It's about support and loyalty. It's about fearlessly jumping up in the air when something works, and sobbing shamelessly on your knees when it doesn't. These are qualities that stand on their own quite well, and don't need a football team for verification. These are qualities that come in handy when you sit down to write an artist statement.

For what better time to be your own best cheerleader, with your head held high and your voice ringing with the conviction of a true believer? Believing in yourself opens the door for others to believe in you. And you don't have to wear nail polish or funny little skirts. Cheerleading is a viable state of personal conviction that helps you write an artist statement that rings true to you, and thus has a fighting chance of ringing true to others.

Revealing The True Spirit Of Your Work

WHAT *IS* AN ARTIST STATEMENT?

The purpose of an artist statement is to create an emotional bridge between the person who views a work of art and the artist who did the work. I came to this realization standing in a small gallery off a wind-whipped coast in Maine, summer of 1989. A trio of seascapes—before, during and after a storm—mesmerized me and I wanted to know: Who did this?

I sought out the gallery owner. Did he have anything about the artist? Of course, he said, and pulling out a resume from his files: dates, education, awards, and the names of shows. I shook my head. It was like handing someone sawdust to chase down an exquisite mouthful of fresh figs.

"Don't you have anything by the artist about her work?"

He shook his head.

"I ask," he said, "but it's like pulling teeth to get artists to give me material about themselves or their work."

I left, round-shouldered with disappointed. The paintings had connected me to a sense of beauty and wildness inside myself, which opened a desire for more connection. I wanted a peek behind the canvas. Compelling art will do this, and it is what artists should fervently hope for and encourage in any way they can. There are magazines, books, and news articles devoted to revealing the habits, hopes and haunts of different artists, both alive and dead. Why? Because we are magnets for each other's stories and how they connect to our own lives, hopes and dreams. Connection is the web of life, and none of us want to be left out.

What inspired this artist? How did she work? Why did she choose this set of images? Had she been at the seaside during a storm? Seen it in a dream? Been touched by someone else's art?

Artist statements, by their very nature, assume that artists reflect on the art they create. This assumption poses some problems. For one thing, private, inner reflections are often "thought reflexes," which do not register very high on our attention scale. If, by chance, we do become aware of our art-mind talk, we often run the risk of critical or denigrating follow-ups. "Uh-oh, who do I think I am? Rembrandt?" This form of self-sabotage, of course, bumps the initial art-mind talk right off the map.

So, the first thing to remember is that the self-reflection of an artist statement is not an evaluation of your work, but a *personal revelation about your relationship to your work and its process.* It is a statement deeply related to the essence of the artist *in relationship to* the essence and process of the artwork.

Some artists feel that they never reflect on what they do, they just fly by the seat of their pants. If you are one of these, hang in, because, believe it or not, the chances are pretty good that you do reflect. The trick is to learn how to catch yourself doing it. Once you grasp the purpose of an artist statement, what it does for you and your viewers, it is only a few more steps to understanding how to write a statement that will represent you well, and honor your work.

If you dig deep enough, you find that an artist statement is an act of self-definition, bound only in the moment that you, the artist, choose. Like your art, which is bound in the material world by its physical manifestation of paint or stone or tile, an artist statement is also bound by the construction of specific words in a moment in time. And like the art it represents, an artist statement can always be unbound, or re-bound again and again. Or deleted. Tossed. Re-written. And all by the artist exercising her personal power of *choice. This* stroke of the brush, not *that* one; *this* sentence, not *that* one.

It never fails to surprise me that artists who are not the least bit worried about committing their art to the physical world of form and content are terrified of committing themselves to the same world of form and content with words. Yet both are self-created representations of the Self that only say: Here is where I am now. . .who knows about tomorrow?

Writing an artist statement benefits you in many, many ways.

For one, it strengthens your bond to your work by actively validating and affirming what you do.

For another, the process of writing about your art increases your awareness. When it is working well, an artist statement has the ability to make you sit up and take notice of your own work in a new light. It may even be influential in pushing you through a transition, or giving you the language foothold you need to swing up to the next level. It may even stimulate a desire in you to play with words in the same way you play with the medium of your art.

The artist statement is also a place where connections can emerge between unconscious symbolism and conscious living. Like your dreams, the artist statement can entertain even the mysterious and unfathomable. Since an artist statement does not have to be a definitive, intellectual comment on your work, but a reflection about your relationship to your art, you can speak about the mysterious and unknowable elements with the same authority, and authenticity, that you use to speak about your choice of materials.

Of course, if you base your work on an intellectual framework or tradition, it would make sense to include this in your statement. Just keep in mind that sharing the intellectual underpinnings, which inform your work, is quite different from making intellectual comments about your work. The latter falls into the undesirable basket of critiquing.

At its best, an artist statement celebrates your work. Just as the process of weaving, potting, painting, or dancing celebrates your creativity and passion, the artist statement celebrates your relationship to your creativity and passion. It also offers a celebratory burst of words for your viewers, which holds the potential to intensify the emotional and intellectual ties already established by the power or beauty or surprise of the work itself.

An artist statement creates a connection, a bond between art, artist, and audience, historically created by proximity and familiarity. It is hard to imagine anyone in Michelangelo's neighborhood needing or wanting an artist statement from him. His neighbors certainly did not need to look up and ask ... who did this? We, however, have created a very different social structure in the twenty-first century, one of disconnection, fragmentation, and dislocation. Yet our desire to know our neighbor has not changed.

An artist statement is simply, elegantly, another way to know our neighbor.

The next question is, how do you go about revealing the true spirit of your work?

First, it helps to have a general understanding of the *form* and *content* an artist chooses when writing a statement.

Hands down, first-person prose is the most effective form. You write in the first-person—*I*—because it is simple, direct, and the most personal voice you can use.

Even though some artist statements are written in the third-person (she/he), this is never a good idea. Usually, an artist does this fearing that the statement, and by implication the art, doesn't have enough authority to be believed, respected or taken seriously. Because authorities write about others in the third person, the artist tries to make it sound as if an authority is doing the writing. But a third-person artist statement becomes easily confused with a critique, and as we have said, an artist statement is *not* a critique. It also drops the artist statement squarely into a lie, since the artist purposefully sets the reader up to believe that someone else, besides the artist, is doing the writing.

Writing in prose works best because prose is a very friendly, very accessible form. Prose lends itself to narration and storytelling, which helps the reader engage with what the artist is saying, which in turn encourages the reader to engage with the art. Once in a while, poetry or prose-poetry is effective, when an artist is comfortable and skilled enough to pull it off.

The content of a statement is made up of specific words, which the artist chooses, and their construction. Several chapters in this book will explore different ways to construct language for an artist statement, as well as address the fears and roadblocks that spring up in the process.

For those who are suspicious of language and its ability to reveal the essence of their work (never mind reflecting who they are as artists), please keep this in mind: words are the medium, not the message, and can be considered "material" in the same way you consider the raw materials of your art. You do not worry about the paint or marble or cello limiting you. In the same sense, you do not need to worry that the words or sentences will limit you either. Your skill in using these is another issue, but as further chapters will show you, these skills are within arm's reach.

The most important thing is what hums beneath the words of an artist statement, which is the relationship you have with your art. This relationship affects what you write, and frames your writing tone of voice. If you connect to the spirit inherent in your relationship to your art, the words you use in your artist statement will dance at your next opening.

It may seem mighty cold at first, before you've actually jumped in, but writing an artist statement is a simple thing.

It is a personal revelation, a reflection on your work, a distilled essence of what you do. It is designed to increase people's engagement with your work by building a psychological bridge between you and your audience.

An artist statement tells people *what*, *how*, and *why* you do what you do. That's it.

PART TWO

WHY WRITE AN ARTIST STATEMENT

Revealing The True Spirit Of Your Work

PERSONAL POWER

The Andean mystics have a theory about personal power: that every being, including each blade of grass, each mountain, each human, has the life-given right to develop to its fullest potential, and that we accomplish this most easily when we recognize the blessings of our personal power as it encircles us within a living bubble of life energy.

But access to our personal power depends upon our ability to be deeply honest about what we know, and what we have yet to learn.

It depends upon us understanding how we diminish this personal power with either an inflated sense of self or a constricted sense of self. Sometimes the driving force of self-doubt tries to hide behind a pumped up machismo of confidence —"Girl! Are you something!"

Other times, it does a one-eighty and heads in the opposite direction. "Whew! Are you *dumb!*"

Both strategies cheat us, and our life, out of the very gifts which life has so graciously bestowed upon us.

The only way to expand our personal power
is to embrace ourselves
exactly as we are
neither more nor less
but as someone in a state of
constantly changing grace.

This is a very challenging idea in our Western culture, where power is primarily experienced as the power over, to manipulate, dominate, rule, and control others; or, conversely, as the power to be independent, isolated from, separated from, to be on one's own. This power of isolation and control is driven by fear. It is a power that thrives on the distance we put between others, and ourselves rather than on our connection to the web of life, which draws us together. The power over is the power of exclusion.

Personal power, on the other hand, is the power emerging from our deepest connections to life. It is the power of feeling, embracing, creating, and celebrating. It is the power that comes when we open up the connection between others, ourselves, and the life-giving energy that surrounds us all. It is the power of inclusion. The power of life.

Making art is a strong way to exercise personal power. So is writing an artist statement, which is an act of self-definition where words, instead of images, draw a clearer portrait of who you wish to be.

When you embrace the artist statement, you expand your circle of personal power to include words about the art that you so willingly create and give to the world.

WHY WRITE AN ARTIST STATEMENT?

Because an artist statement affirms what you do, and by extension affirms you. And none of us can ever have too much affirmation.

Because an artist statement calls out for you to recognize the true faces of your deepest self: truth, beauty, and goodness.

Because an artist statement invites you to experience another level of awareness about yourself and your art.

Because an artist statement strengthens the relationship you have with your work.

Because an artist statement builds a compelling bridge between your audience and your art.

Because an artist statement enriches the connection between the artist and the art.

Because it is practical. You can use your artist statement for:

- Portfolios
- Brochures
- Galleries
- Catalogs
- Press releases
- Media articles

- Art festivals
- Exhibition/performance notes
- Biographical notes
- Applying for grants
- Applying for teaching positions
- Applying for artist-in-residence

Because it makes a deeper statement about self-trust, that you trust yourself enough to flow into another dimension of expression.

Because it is a powerful experience to use the tool of language to support what you love.

Because you can.

WHAT YOU RESIST PERSISTS

The next hurdle is the writing. For artists, who are immersed in all manners of visual, auditory, and kinesthetic idioms, words often feel like shackles. There is a deep mistrust of language that shows up as "My art says it all," or "I have nothing to say." Which really translates into "I have nothing of importance to say," as if we cannot face the authority of words that might end up belittling us through misunderstanding or sheer inaccuracy.

It is a good exercise to challenge this assumption of "I have nothing to say" by trying on the opposite response, just for fun. Pretend that you do have something to say, that you already have a treasure chest full of valid comments about your art. Because the fact is, you do.

In spite of your fears, or self-confident protestations, there is an unself-conscious language that you use every the time you think or speak about your work. Sometimes this happens when you spontaneously answer someone who asks, "So, what are you doing now?" Or when you find yourself thinking about what just happened in the studio. The trick is to learn how to catch your own unself-conscious language, and then deliberately write it down.

Easier said than done?

Try out the next three exercises:

• *Release your resistance and trust that you have something of value to say about your work.*

How?

Try this HOT-AIR BALLOON EXERCISE:

Imagine your resistance is a tangled mess of musty, torn, rough cloth spread around you. Gather it up and deposit it in the basket of a hot-air balloon. Tuck in every edge that tries to sneak out. Give the high sign to the navigator, then watch the balloon rise up into the sky, with all of your resistance crumpled in the bottom of the basket. Watch as the balloon becomes smaller and smaller, a mere speck on the horizon. Watch and notice how you become lighter and lighter, until the balloon and your resistance disappear altogether.

When you look back on the ground, there is a luscious length of silk in your favorite color, the color of self-trust. Pick it up. It smells like spring, like apple blossoms. Wrap yourself in it, hold your head high and walk straight to your private writing room.

•*Pay attention to every single thought or comment related to your work, before the "throw away" machine kicks in.*

How?

Start with making the declaration that you will do this, out loud. To yourself. To your loved ones.

Ask those around you to point out when you are talking about your work. When you catch yourself saying something, take notice. If you wish, dig for more by asking yourself, "What did I just mean by X ?"

The nature of paying attention gathers speed of its own accord. Before long, and with little or no effort, you will become acutely aware of each thought and comment as it rises out of the swamp of your neglect.

• Begin to establish credibility, for yourself, by jotting down every thought and comment in a notebook, unedited.

This notebook must be your detective collection bin, a democratic holding box. Do not make the mistake of keeping it for the exclusive, perfect thought, the Immaculate Conception. You will need all the clues that, up to now, you have been discarding. Neat ones, messy ones, jubilant ones, half-hearted ones, party ones. At this point, everything is equally important. Use it all.

Have a thought you don't like?
Write it down anyway.

Sometimes the best material rises up in protest to what it can push against. The paradox? Under the right conditions, actively resisting undermines resistance.

Since the nature of resistance is to push back, the more you resist writing your artist statement, the more you empower it to be an immovable object of imponderable proportions.

Give yourself permission to write, warts and all, and you will have broken the spell of persistent resistance. Then the frog and you can ride off together into the sunset.

PART THREE

WHO USES AN ARTIST STATEMENT

WHO INDEED...

- Galleries
- Retail Stores
- Art Festivals
- Craft Shows
- Exhibitions
- Contests
- Grants
- Family
- Friends
- Art Patrons
- Places you teach
- Degree Applications
- Journalists/Writers
- You, when you're clever
- Your Local Chamber of Commerce

FROM CHICAGO TO MAINE

From Chicago to Maine, from Boston to New York, gallery owners agree on two things: The most elegant artist statement means nothing if the work does not speak for itself. Anything less than a realistic, intelligent, and accessible artist statement is a useless addition to any portfolio.

Judith Leighton of the Leighton Gallery in Blue Hill, Maine minces no words. "If artists don't accomplish what they are trying to say with their art, the artist statement won't validate what's not there. It is absolutely embarrassing to read an artist statement when the artist makes it sound grand and wonderful and magical, but the work can't hold its own. If your work doesn't convey it to me, then I certainly don't want to read about it."

In the world of art, an artist statement qualifies as an essential grain of sand; and, like the sand traveling home with you from the beach, it crops up everywhere. Requests for an artist statement may come from gallery owners for an exhibition, from writers for an article, in grant applications for money, from publishers for a book, or for positions as an artist-in-residence. In the hierarchy of professional *musts*, an artist statement is, admittedly, low on the totem pole. But it is still very much on the pole. After the work itself (No. 1), and the resume (No. 2, for collectors & investors), the artist statement brings up the caboose. But like the small, ubiquitous business card, a well-crafted artist statement marks you as a professional and will be used over and over again.

"When artists have come to the point of showing in a gallery like mine," says Nancy Margolis, of the Nancy Margolis Gallery in New York City, "they are pretty organized and professional and ambitious. They have learned how to put a portfolio together, including the artist statement; otherwise, they would not have gotten this far."

For the gallery owner, a good artist statement gives off the glow of a professional paying attention to detail. It might not make the difference between one sale and another, but, when done well, the artist statement makes the gallery owner's life easier, and adds spit and polish to the overall effect of the *artist-as-person*, which in turn compliments the *artist-as-artist* and the *artist-as-investment*.

For many gallery owners the effectiveness of an artist statement is considered an ally for the artist and the gallery. Frank Paluch of The Perimeter Gallery in Chicago, with the annual exhibition of *The Nude In Clay*, has used artist statements as a part of the artists' package for the entire nineteen years he has been with the gallery.

"The artist statement," he says, "provides an illumination into the artist's psyche, their relationship to their own work, and functions as an educational piece."

For John Elder, of the John Elder Gallery in Chelsea, in New York City, the artist statement is de rigueur. "For each show, we collect a lot of information from the artists," John says. "There's a book at the front of the gallery, which includes resumes, an artist statement, our press release, slides or color copies, and articles about the artist. If an artist statement is missing from their packet, we request one. Many times, we pull sections from the artist statement for our press releases."

In general, gallery owners describe an artist statement as the artists' summation of how and why they work, and what they do. Sometimes, it is a summation of how the artists want their work to be viewed by the public. Either way, it is the artist's viewpoint, in a sea of viewpoints. The tricky part, for gallery owners, is to get artists to pay attention to their artist statement and consider it time well invested.

"Sometimes it is so very hard to get written things from the artist, even basic information," says Nancy Margolis. For the really difficult ones, we end up doing it for them. We'll take whatever they give us and throw it together, clean it up."

Some gallery owners may be disposed to hold hands with a particular artist, but in the end, their respect goes to the professional artist who comes to the gallery prepared and ready to go.

WORKING OUT
IN THREE PARTS:

RECLAIMING YOUR STORY

REFRAMING YOUR FEARS

THE ONLY WAY OUT. . . IS THROUGH

PART ONE

RECLAIMING YOUR STORY

WHO IS THE GATEKEEPER?

Fully equipped with a body, mind and soul, each one of us holds the keys to the gateway of our own being, keys that allow us to fulfill ourselves to the greatest of our ability, to unfold and become who we are.

For some of us these keys are obvious: paints and brushes, a hammer and nail, the ballet or flute. Another key, which we all share in common and is even more obvious, is language, the tool of our awareness.

Yet many of us have turned our backs on this dimension of our experience. We use it out of habit and necessity, but falter when it comes time to use it with full, aware intention. We don't do this with our hammer and nails, our ballet and flute, our paints and brushes. So why do we do this with language?

When did we hand over this useful key, which has the potential to open the essential gateway to our being? And who stands at the entrance, leering at us, dangling the key of language just out of reach until our shoulders slump then we turn and walk away?

How is it that those of us who are so receptive to the images pouring from our artist soul, are painfully afraid of our own words pouring from this very same source?

How did we become so suspicious and jaded about such an essential part of how we express and experience, who we are?

HOW INDEED...

Revealing The True Spirit Of Your Work

REVEALING YOUR STORY

Words are a big deal. No matter how many times we chant, "sticks and stones can break my bones, but words can never hurt me," some part of us knows this is not true. True, they can't break bones, but that's because words don't operate in the physical dimension. Jump into the emotional dimension and it's a very different story.

Centuries ago, words were thought to be capable of casting spells and driving out demons. History is replete with lovers wooing the loved one—not with wine, or flowers, or the crown jewels—but with the humble word. Politicians today know full well how they are chained to their words, which can turn entire lives upside down in an instant. Verbal abuse is even acknowledged in our legal system as a source of real damage.

It is odd, when you think about it. After all, words have no taste, no smell, no sound, no color, no texture ... they are, actually, almost nothing. And yet, they are everything. Why? Because, like your art, they have the power to excite our imaginations.

Take our first names. Just one word. Only a few letters scratched out on some surface, a few syllables floating through the air. But what a presence! The simple sound of our name being called out can stop us dead in our tracks. Words are a big deal.

Words are also our birthright, for language is as basic to the human psyche as bones are to the human body. Even when people can't speak or hear, they will still create words out of movements, signs and symbols. Remember Helen Keller? A child without words, without language? Lost in a cave of imponderable loss until she was given one word: *water*. With a single word she could organize life. Words are a big deal.

Human beings create words because they are the basis of language, which is the basis of thought. Just as blood is to our circulatory system and breath is to our lungs, so thought is to our minds. Which is also why we easily overlook our words and take them for granted. They are there all the time, like our breath, like our blood, and who needs to pay attention to these?

Many artists, who create worlds out of images or sounds or movements, think their worlds exist in a different universe from the world of words. In fact, this illusion is so powerful that many artists believe that their creations have nothing in common with words.

Fast forward to one of these same artists whose work hangs in a upscale gallery in Manhattan's Soho district. Wander in and look around. People cluster together, whispering as they look at the work surrounding them, speaking *words* about what they see. Some may even be writing in a notebook—more words. Some may be silent, just thinking to themselves—more words. The truth is, words about anyone's art are inescapable.

You may crave nothing more than to pull back into your studio shell, but eventually someone is going to ask about your work, and how will you respond? Gesticulate? Roll your eyes back into your head. Get down on all fours and paw the ground?

Or, perhaps wing it with a few words, which are so casual that they won't appear to matter. Or maybe you will use the opposite strategy, overindulge, and spew out a torrent of words. Either way, when you are convinced of the triviality of words, of their utter irrelevance to your work, you lose the personal power to influence whatever effect words, most assuredly, have.

This is especially unsettling as other people, besides you, begin to own the words around your art: the critics, collectors, historians, journalists, and the casual observers. When artists fail to proffer their own words, a vacuum is created for others to fill. After a while, the accumulation of these other words starts shaping a collective perception about an artist. True, this will happen in any event, but the story unfolds in a completely different direction when the audience has to consider the artist's perspective alongside its own.

And why not reveal your story, the artist's story? Storytelling is a long-revered pastime, one of the most ancient and compelling of all our human rituals. Whenever we engage in storytelling, we enter into the realm of the collective, pouring our story into the communal pot.

Understanding and naming what we do, with language, does not dismantle the beauty or mystery of what we do; though, as artists, we fear this. Our fear of the printed word gives us the sense that it irrevocably fixes something in time and space, when it is actually no different from an artist choosing this lemon, not that vase. This red, not that yellow. This curve, not that angle. When we use words, we enact the exact same kind of selection, exercise the same freedom of choice.

Sometimes the world of words does capture the world of our senses, and we feel pure delight in the connection. After all, what is more organic to humans than language? First baby words proclaim us even before our first baby steps. So why is it that, as adults, the deep pleasure of our own words eludes us when an opportunity like the artist statement pops up?

I suspect it is the dicey combination of art criticism and formal education. The first promotes language in service to noble judgments—with the emotional emphasis on "judgments." No matter how cool we wish to be, criticism and creativity make awkward dance partners, with words taking the lead. It doesn't matter if the words wound or uplift, their power to do both is what often dominates communication and gives us the unbalanced sense that words are an untamed force.

As for formal education, it unwittingly taught us to mistrust our own words. In our first twelve years of formal education, the balance of power lay with someone else telling each of us *when*, *where* and *how* we could, or could not, use *which* words.

When the private language of our hearts and homes shifted to the public, social language of the schoolhouse and schoolyard, we learned quickly and painfully that an acceptable social and public language must replace our deeply personal connection to language. As necessary as this transition was, it also implied that the language closest to our hearts was, somehow, not acceptable.

So we learned to walk the edge between public and private language and not fall off. But, the vexing vigilance we had to maintain created a deep mistrust in our relationship to language. After years of conditioning, the mistrust smolders underground, mostly unnoticed, until our words are thrust into a context like the artist statement, which creates a volatile mixture of private language open to public exposure and the attending judgments (criticisms) of others.

Suddenly, every thought we ever had about our work vanishes. Poof. Like a pot collapsing before it can be taken off the wheel. We are convinced that we have nothing to say about our own work, or for certain nothing of value. We throw our unformed thoughts back into the scrap bucket, turn out the light and head out of the studio. Or we fake it and end up with insubstantial, or overblown, words masquerading as us.

In spite of the self-conscious fears about writing that you were given in school, in spite of the judgmental authority of justified, or unjustified, art "criticism," the good news is: *you can recover your own words*. The unself-conscious language, which you use all the time when thinking or talking about your work, is right there under your tongue. All you have to do is imagine that you have *a lot* to say about your art, which is neither self-important nor trivial, but relevant, revealing, and wonderful. And you will.

PART TWO

REFRAMING YOUR FEARS

RESERVATIONS / MOTIVATIONS

Given that so many other people take liberties with words about an artist's work—the critics, the writers, the viewers—one would think that artists would snap at the chance to stake their claim. Not so. For many artists the written language is fraught with land mines and they simply prefer to hang out in the country of the Strictly Visual.

One of the most common responses an artist gives, when asked about an artist statement, is a variation of "My work cannot be reduced to words," as if words were evil alchemists ready to turn an artist's creative gold to dust.

One way to work with this resistance is to tackle it head on, with a *WRITING EXERCISE*. If you are not ready to write, right now, I suggest you close the book and wait until you are. Why?

Fact: if you continue reading and don't do the exercise, you are less likely to do it at all. But, if you stop now, then when you pick up the book next time, it can be with the intent to do the exercise. And, if you just continue reading without doing the exercise, you'll spoil the chance to see how your writing matches up with what I say afterwards.

So, be a sport.
Get ready to write (turn the page)
or pack it in for the night (close the book, no peeking.)

Do the following two exercises back-to-back.

Each one takes three minutes.

Preparation takes five to ten minutes, depending on how organizationally challenged you are.

Even busy-little-old-you has time for this.

RESERVATIONS: WHAT HOLDS YOU BACK?

[Writing Exercise #1]

Grab two or three pieces of writing paper. Or a notebook. Or a journal. Grab a pencil or pen. Or, if you're feeling adventurous, grab a huge sheet of paper and a chunk of charcoal, maybe a crayon.

Get close to a timer, preferably a portable one that you can place near your writing space. Mine happens to be attached to my cooking stove; so if I need to use it, I park myself on the kitchen floor.

Get in a place where you can write comfortably and *furiously fast*.
Yup, fast!
Writing fast makes it easier to ignore your
seventh grade English teacher.
Writing fast overrides whatever tries to shut us down.
Writing fast ignores the rules.
Writing fast–*Keep that hand moving!*–pushes us over the bumps.

Mince no words.
Forget about complete sentences.
Just fume and fuss!
Here, you get to meet the Doubt Dragons face to face.
Paper exposure turns their breath of fire into so much hot air.

Think of it as a kid's game,
no winners or losers,
just beat the clock.

After you set the timer for TWO MINUTES, write as fast as you can,
all the reasons you do not want to write an artist statement.
STOP when it dings! (There's always mañana.)

Get set. . .GO!

When you are finished,
I suggest dropping all of this writing in a folder,
without a second glance!

This is no time to engage your inner critic.
Right now, process is everything and the artist statement,
as a *product,* is still just a glimmer in your beginner's eye.

Motivations: What Keeps You Going?

[Writing Exercise #2]

Ready for round two?

After you set the timer for TWO MINUTES, write as fast as you can,
every reason you can, want to, and will write an artist statement.

Be as fanciful, fantastic, and playful as you wish.
Here you get to engage large visions.
You get to affirm why you do your art
and at the same time
send a powerful message of intent to your best ally,
your sub/super-consciousness.

Remember, keep that hand moving!

Get set. . .GO!

[Again, *put this away*. You have done all you need to do, for now.]

Did you know that every reservation you hold can be turned upside down? Right side out?

That the ultimate shape-shifter is fear flowing into, and becoming, a motivation?

THE SEVEN DEADLY FEARS

Artists who routinely tackle twenty-foot sculptures, or hike deep into the wilderness for that perfect scene, often stand paralyzed beside a blank piece of writing paper. When the small artist statement looms large on the horizon, even the most confident professional can end up shuffling papers and sharpening pencils, or clicking files open and closed, surfing the web, anything at all to forestall the daunting task of translating their precious visual, sound image, or movement into what feels like the doomsday of words. But, why so much resistance?

Because of seven deadly fears.

Keep in mind that any fear, no matter how small, robs us of vital, creative energy; and none of us, least of all artists, can afford such a waste.

The good news is that once you identify a fear, you have choices. Conversely, if you fail to identify a fear it rolls on unopposed, slashing and burning all possible options in its path.

Once you *Name That Fear,* here are some of the prize choices you can take home with you:

• *Do I need to even respond to this fear? Should I pay any attention to it?*
Most fears need some attention, that's why they are fears in the first place. If this choice comes up, chances are it is a low-maintenance fear that you can clear up with a minimal, but appropriate, response.

• *How afraid of this fear do I really need to be?*
Obviously, if a wild rhino has lowered its massive horn and is charging you, being afraid is a good thing. On the other hand, fearing your sister-in-law's sharp tongue probably doesn't rate more than a yawn. You can rate your fear by how loud your heart is pounding, or by using the 1 to 10 scale.
One, I don't need to be afraid of this fear hardly at all, so I can...
Ten, Oops! Wild one out of the corral! Run? Or, jump on for the ride?

Experiencing fear, as with any emotion, is not an initial choice. It just arrives on your doorstep, like any experience. Once it's there, then the choices begin.

One is the fear choice: How afraid of this fear will I be? Sometimes the feeling of fear kicks up its own reaction and then you have overlapping layers, or fear lasagna. Once this happens, your chances for choosing fearlessly diminish rapidly, and you just end up hanging on until the fear-ride pants to a stop. If you learn to recognize the *fearing of fear,* your response has a greater chance of keeping that buckin' bronco under control.

• *How much time and energy am I going to spend on this fear?*

You may, or may not, have control over what creates the fear in the first place, but you always have control over your response. If not your initial response, then your second or third one. You could say, "Yes, I'm afraid of X, but I'm turning my attention to: making a pumpkin pie, going to sleep, joining the circus...the list is as creative as you want it to be.

You can also use the 1 to 10 scale to determine specifics. For instance, "One to ten, I need to spend an hour paying attention to this fear?" Once you ask this, you will get an instant response inside yourself, say "three." The trick is to catch that first response before your argumentative, doubtful mind takes over and muddies the waters with, "Well, maybe it *should* be a seven..."

If you fly straight into confusion, as you ask a 1 to 10 scale question, your fear factor just sailed over the top. Consider it a ten.

• *Or, you may decide to step right into the saddle and go for the ride.*

In this case, keep in mind that fear is never in service to life, and when the ride is over, it's a good idea to go back and reassess any decisions that might have bounced out of you along the way.

A few notes about fear:

> • Each decision or choice we make—from *which socks to wear* to *which job to take*—can be traced back to one of two springboards: the one that supports life (life-affirming) or the one that supports fear (fear-affirming).

> • When we are frightened and fail to stand up to fear, we are in effect saying that fear is more powerful than we are.

> • And the opposite of LOVE is...? Yup, fear. Hate is actually love turned against itself.

> • Living in a state of fear makes you feel cheated, as if you can never have what you want.

> • Which will you serve? The fears of your personality, or the life-affirming instincts of your creative soul?

The most common anxieties that artists face, when they start to write their statement, are the seven deadly fears, which often start out as quiet and unassuming reservations. The low-key disguise is utterly disarming. A reservation is so rational, so reasonable. But check out how cleverly a reservation hedges when you try to take a good look at it. *Scrutiny* is the scourge of all fears.

Take heart, for what begins as a discouraging reservation can often be turned into an inspiring motivation.

THE PEACOCK TRAP

(FEAR $^{\#}$1)

THE RESERVATION:

If I flash all of my gorgeous tail feathers and write what I *really* want to about my work, people will think I'm egotistical, self-serving, and arrogantly self-important.

WHAT'S REALLY GOING ON:
This is fear of Word Magic.

It works like this: deep down, you believe that words hold a mysterious power, which automatically makes something true about you. Of course this "something" is always a bad thing. Somehow, this same mysterious power evaporates when you try to use words to say something good about yourself.

Under their spell, words become evil magicians who render you incapable of writing a valid, engaging and honest perspective of your work. In a flash, your naturally gorgeous tail feathers are turned into the gaudy fans of a chorus girl.

LET'S REFRAME THIS:
Words are tools I use in service to my art and myself. How I use them is my choice. What I say and write is within my control.

Writing about my work indicates that I take my own work seriously, which encourages others to do the same. Showing off my tail feathers, *besides being fun*, models for other people that it is okay to show theirs.

REALITY CHECK:
On a scale of one to ten, how much value do I place on helping others better understand my work? (1 = not much / 10 = a lot)

FAMOUS LAST WORDS

(FEAR #2)

THE RESERVATION:
"Words can never express the true nature and beauty of my work. My work speaks for itself."

WHAT'S REALLY GOING ON:

This is not so much a reservation as an out-and-out dismissal. And it sounds so positive, so genuinely life-affirming: "My work speaks for itself." How grand. How supportive of one's work. How independent and self-assured.

If only this were true.

When fear shows up at the ball in this outfit, it's pretty tricky to figure out who's hiding behind ye olde positivity mask. One telltale clue is that fear has no flexibility, none, rigid to the core. On a scale of one to ten, is the speaker here ready to entertain a different opinion? Zero.

In this case, language becomes an evil magician capable of diminishing your work with one wave of the word wand. Presto! The incredibly shrinking artwork! By the time Diabolically Clever words are through, you couldn't find your work with a high-powered microscope.

Or perhaps words might reveal something you fear about your work. That it is not all you've cracked it up to be? That you're a fraud? That, in the Land of Oz, there is someone else behind the curtain?

LET'S REFRAME THIS:

Your work speaks for itself, absolutely true. It cannot speak for anything else but itself. The exact same thing is true for an artist statement: it can only speak for itself. One medium does not sabotage or usurp another. It just expands its influence. Words add another layer to your work, enriching the dimensions of self-expression.

Keep in mind that revealing is a winner's game. Of course, fear really, really wants you to believe differently, because once the truth is out, it is fear's power, which shrinks, nay *shrivels* up.

When you reveal, you invite connection. When you invite connection, you open up the channel for good things to flow toward you. Yes, the opposite might happen (fear stage whispers), but when you have nothing to hide (that's what revealing is about, not hiding), the fear that might be exposed is preempted. Nothing to hide means there is nothing to expose.

Understanding does not dismantle the beauty or mystery of your art. There are many layers to your work, and each one increases the rich, bronze patina of your self-expression.

REALITY CHECK:

On a scale of one to ten, how much fear is behind my resistance to writing the artist statement? (1 = not much / 10 = a lot)

SCRAMBLING

(FEAR #3)

THE RESERVATION:

How can I really judge the value of my own artwork? I'm way too close to it. Doesn't everyone love their baby, no matter how ugly?

WHAT'S REALLY GOING ON:

The fear of scrambling for a finger hold on the rocky slopes of an artist statement, and grabbing your own hot air, is a tangle of LOI and SDSS.

Lack Of Information: An artist statement is not the place for you to "judge" your work. Quite the opposite. Ground zero for writing the artist statement assumes that you have momentarily suspended all judgments, good, bad and indifferent. Remember, *an artist statement is not a critique*. An artist statement reveals something (not *everything*) about your relationship to your work, whatever you choose in order to give a sense of the "you" behind your art. The key word here is *choice*. Yours.

Silly, Dubious Slights of Selfhood: Admittance to all chapters of SDSS requires endless nail biting about how you will bring ridicule and scorn raining down upon you and your work.

This fear is not entirely unfounded. Embarrassment happens, especially when a part of ourselves insists on taking the wheel, while another part of us looks the other way, ignoring the unmistakable hunch...tap, tap, tapping on our shoulders.

One sure way to embarrass ourselves is by keeping the "I'm not good enough" boulder snug against the entrance to our Self. This kind of emotional fear prances around as our protector and whispers that BIG, FANCY, DRESSED-UP words will carry the day.

On the other hand, endless nail biting is self-defeating, not to mention rendering your hands unfit for company. Fear of any kind, small, medium or large, is self-defeating. You might embarrass yourself, you might not. Either way, it's only a small bump in the road and certainly never a reason to forgo writing your artist statement. Besides there are ways to minimize, if not eliminate, the possibility of a major faux pas.

LET'S REFRAME THIS:

To mine own self be true. If I don't know my own work, who does? What better qualification do I need to write an artist statement? When I own my work, with authentic and alive words, it adds dimensionality and a richness to the life of my art. In the end, the best protection against embarrassment I can exercise is arming myself with the truth, and the skill to reveal it. I hold the truth about my art and myself, and I hope this book will teach me the skills. (It will.)

REALITY CHECK:

Paying attention is the only remedy for committing acts of SDSS. As an exercise, remember three times you have embarrassed yourself. In looking back at each instance, do you remember hearing or feeling a quiet inner voice trying to turn you in another direction? That voice is your best friend, who you turn away from at your own risk.

OPEN FLANK

(FEAR $^{\#}$ 4)

THE RESERVATION:
Writing an artist statement will inevitably expose me to criticism.

WHAT'S REALLY GOING ON:

You can always identify a run-away, global fear by how it hides behind a fall guy. In this case, the artist statement. The fear of criticism will grab onto anything to defend its position, even the way a stranger looks at you in the supermarket.

This fear is very clever. Look how it positions itself as a positive statement, as if the statement itself were in fact, a fact. Global fears, in their never-ending conquest of new territory, come across as the sure guys. I guess when you are invading another country, looking timid doesn't work too well.

Run-away, global fears feed on a steady diet of self-doubt. This is important to know because a run-away, global fear of criticism is not about the criticism. Of course, if fear can shift your focus to the criticism, it's won. On the other hand, if you tackle the real issue of doubting yourself, then the fear of criticism beats a hasty retreat. Actually, if you listen closely to that quiet inner voice, you will discover that not all of yourself is in doubt.

LET'S REFRAME THIS:

When I write an artist statement, I create new connections between myself and my art, between my art and my viewers, between my art and my heart. When I write an artist statement, I expand my horizon of self-expression, increase my ability to open up the creative floodgates, which ultimately flow right back into my work. We all win.

REALITY CHECK:

On a scale of one to ten, I feel attacked when someone gives me feedback of any kind. (1= not much / 10 = a lot)

On a scale of one to ten, I turn criticism into a comment about my self worth. (1 = not much / 10 = a lot)

THE INTIMACY ISSUE

(FEAR #5)

THE RESERVATION:
People will be appalled by what I reveal in my artist statement and will judge my work by that.

WHAT'S REALLY GOING ON:

This is Fear of Intimacy, in top hat and cape from Transylvania.

Its game is to convince you that hiding out is safe and revealing is dangerous. Come on, reveal that sweet little neck...

Like any self respecting Fear Vampire, this one sucks the living energy out of a genuine truth: that connection between the artist and the viewer is a good thing. So, yes, in this scenario, the artist statement does its job and creates connection...only not one you'd want. The fear vampire feeds on your suspicion about the artist statement, and turns its very nature—to create connection—against itself.

And in case that's not enough for you to wear a steel turtleneck to bed, it further insinuates that what you reveal about yourself has the power to destroy the reputation of your work.

This fear preys on the parts of you that have always felt safer hiding out. I don't care how prettily this fear vampires dresses up, its mission is to make you believe that revealing who you are is your own worst enemy. Don't believe it.

LET'S REFRAME THIS:

My work is my work. My artist statement is my artist statement. They complement each other, but they do not rescue each other. They support each other, but they are not joined at the hip. Each rises, or falls, on its own merits. They are both, in their own way, extensions of my creativity and my passion. Neither one has the power to do the other one in.

When I write an artist statement, it reinforces people's memory of my work while showing respect for people's natural desire to know why I do what I do. Revealing my relationship to my art, with honesty and verve, builds connection and confidence.

Hiding out supports my fear. Revealing supports my strength.

REALITY CHECK:

On a scale of one to ten, how much value do I give to my own work?

(1 = not much / 10 = a lot)

(Hint: If you have little value for your own work—anything from a 1 to a 5—revealing yourself in an artist statement would be developmentally inappropriate. Your first order of business is to assess why you are creating art in the first place.)

COMMITMENT SUPER GLUE

(FEAR [#]6)

THE RESERVATION:
Words will imprison my work, lock it up forever in the damp, musty dungeon of time and space, from which there is no escape.

WHAT'S REALLY GOING ON:
This is Fear of Commitment, version 101, with a dab of Word Magic thrown in to make sure it sticks. Dare to write down one little thing about your art, and you are *forever* committed. Words, unlike your precious art materials, have the magical power to make whatever you write real and unchangeable. As if the act of writing something down on paper establishes its own tyranny. (If you run for a political office, this might be a real problem. You're not. The "live and let live" factor is a lot higher in the art world.)

LET'S REFRAME THIS:
Being born is a commitment. So is breathing. Choosing that marble or that cello is a commitment. Commitment, being emotionally or intellectually bound to a course of action, does not mean you can't change your mind. If staying committed to a course of action or a position is working, stay committed. If it is not, then choose another direction.

An artist statement is no more bound in space and time than your art. Each time you glaze a pot or weld an iron rod, you have just "committed" yourself. Ah, but that's growth, you say. One week I'm doing this and the next week I'm doing that. I'm growing, my art is evolving.

Yes ... and the artist statement can grow right alongside you. That's the whole point. When your work changes, so does your artist statement, *by the power of your choice*. Writing an artist statement is a rite of passage that affirms the complexity, depth and richness of your artist life. The sense that anything can be permanently fixed in cement is an illusion. Given time, even cement crumbles.

REALITY CHECK:
On a scale of one to ten, how committed am I to my work? (1 = not much / 10 = a lot)

FLAKY, FLIGHTY FITS

(FEAR #7)

THE RESERVATION:
I'm concerned that what I write, in an artist statement, will end up confirming the myth of the flighty, flaky artist.

WHAT'S REALLY GOING ON:

This whimsical, almost innocent sounding fear is actually the most dangerous of all: Fear of Your Profession.

And it has nothing whatsoever to do with writing, or not writing an artist statement. Like all run-away, global fears, this one will latch onto any excuse to throw a fit.

When this fear comes up, look at how you've been conditioned to believe that a "professional" artist is an ox-y-moron: an idiot yoked to a big lumbering beast that goes nowhere very slowly. Once you place your own doubts about your chosen profession on the table, you will be looking at the real issue, and not shadow boxing with different parts of your artist portfolio.

LET'S REFRAME THIS:

A myth is a small truth running at top speed through the countryside, gathering layers of notoriety along the way. By the time it reaches the other side of itself, it has crystallized into a Big Communal Belief. What was *is*, and always shall be.

Trying to stop a myth is like trying to knock down a Sumo wrestler. I suggest you walk away. Give it the old, cold shoulder. It's not worth even a nod. Swing your attention, *and intention*, over to what you love. You are the one in charge of how you use your energy.

Over time, as artists take part in the Revelation Revolution and reveal the true spirit of their work, slowly but surely another story will spread through the village.

REALITY CHECK:

On a scale of one to ten, how much do I believe that my work has a place in the world? (1 = not much / 10 = a lot)

PART THREE

THE ONLY WAY OUT. . . IS THROUGH

As in the beginning of this book, we are at a point where you can choose different paths:

TAKE A BREAK
or
LET'S KEEP GOING

The TAKE A BREAK path is really a misnomer, because you will be continuing the same process, you just get to take a break from reading. In this choice, you take time off to gather material for your artist statement, before working with the specific writing exercises that follow.

Do I recommend this? It depends on your personality, learning style, and whether or not you want to go with the grain of your nature or try swimming upstream just for the heck of it.

TAKE A BREAK works well for those who are most comfortable with a taste of what's to come, who like to stick their big toe in the water to see how cold it is before jumping in, for those who are not thrilled with surprises.

It also works well for those ready to let what they've read thus far settle into the folds of their brains. *Plateauing*, I call it. This is a classic creativity strategy: cram tons of information into your brain system, and then ease up on the gas pedal and coast for a while. Take a shower, take a nap, go for a walk. Let your brain idle, humming quietly along to the tune of the breeze, the sunlight, the whispering leaves. Take an hour, or two. Take a day, or two, or three.

The trick is to allow enough time to slide by for brain synthesis, but not so much you end up stalling out. Another trick is choosing activities that are not a jar full of stimulation, like movies, or big dinner parties, or a trip to Disneyland. Distraction creates distance between you and your artist statement. *Plateauing* pulls you closer.

Actually, TAKE A BREAK is a good option to leave open for yourself any time it feels right. For the developmental rhythm of this book, that time is now.

On the other hand, if you feel like plowing straight ahead, you won't lose out. All of the "gathering up" exercises I outline for the TAKE A BREAK option, show up again in later chapters.

TAKE A BREAK

Imagine a basket overflowing with artist statements. They fairly ooze over the sides, all magenta and teal and amber. They smell heady, like the air after a storm. Fresh. Vibrant. Dancing with energy. Some are loose collections of words. Some are sentences so long they fill up a whole page. Some are word pictures with no frame. Some are stacks of shapes, stars, diamonds, ovals, crinkled lines, torn edges. Some are cold as ice. Others, flames of possibility.

Your task is to take some time off from reading and fill up this basket.

In the gathering stage, everything works, nothing is thrown away. The good, the bad, and the indifferent, they all land in the basket, tumbling over each other. In the gathering stage, every censor is sent to Censor Hall to sit at long tables made of hard oak and bore each other with tales of critical woe. In the beginning, there is no censoring. Every single thought gets to mingle with every other in a very democratic basket.

Following are a few suggestions. But, *please*, free yourself to find your own way.

Keep in mind that dull ideas have their rightful place in the developmental scheme of any creative process. You often have to pour out the mundane, the boring, and the trite before the bold, kaleidoscope ideas have enough room to dance. Remember, *judge not* less ye freeze up your wonderful, wacky idea machine.

Take a small spiral notebook with you everywhere.
Write down any phrase that comes to you about your work in:
A conversation,
A daydream, a night dream,
In the car, in the studio, in the shower,
Anywhere inspiration drops into your lap.

If you keep a technical notebook, add commentary to it.
What were you thinking as you mixed that midnight blue,
centered that large vase,
or whittled that piece of mahogany?

If any articles have been written about you, look at your quotes.
Without realizing it,
you might have said the perfect thing.
Write this in your notebook.

If tape recorders work for you,
take one into your studio and jabber as you work.
Or in the car,
or on a walk.

Do what works for you; design your own gathering program. This is as good a time as any to practice trusting yourself.

<div align="center">

You will know when you have finished.
You will know when you want to move forward.
You will know when it is time to pick this book up again.

You will know.

</div>

If, however, six months goes by before you pick this book up again, just notice, *without judgment*, that six months have gone by and don't go reaching for the cat o' nine tails. There is no right or wrong way in this process. That does not mean there is nothing to measure against. There is what works and what doesn't work. If six months goes by and that worked for you, then it worked for you. If it did not work for you, then simply choose again. Whenever we discover what does not work, it takes us that much closer to what does.

LET'S KEEP GOING

(This path is pretty straightforward.)

THE POWER OF INTENTION

The power of intention is a simple practice, one that blends the spiritual with the psychological and the practical. Before doing something, anything, bring your conscious attention to what you are going to do and make the simple declaration that you intend to do it.

From a practical standpoint, making a specific, conscious declaration—I will write an artist statement—gives you a clear end point. This way you know where you are going, and can assess whether or not you have arrived. If you have no end point, you will drive around aimlessly, literally driving yourself to distraction. We certainly don't try this when we get in a car. "I am going to Chicago," lets us know that, when we end up in New Orleans, we must have missed a turn somewhere.

Writing an artist statement is a project, not an endless process. At some point, all the exercises will have been done, or not, and you will write an artist statement, or not. Either way, because you declared your intention to begin with, you are not lost. You know where you are, or where you are not.

From the psychological dimension, declaring your intention up front allows you to line up behavior to match your intention. One of my pet peeves is when someone says, after the fact, "I'm sorry, I didn't intend to hurt your feelings." I always want to say, "Well, if *you* didn't intend to do that, who the hell was driving?"

Intention is our internal awareness about something we are thinking about saying or doing. Our specific behavior is the external manifestation of that intention. When these two, intent + behavior, don't add up, it lets us know that inbetween them there is a gap where the behavior does not accurately reflect our intention. So, I intend to cross the street when the walk sign lights up, but in fact, I step off the curb before the light changes and a car nearly hits me, angrily honking its horn. One of the characteristics of an intention/behavior gap is that we often get ourselves into trouble, that's why we end up saying things like, "I didn't intend to..."

By declaring our intention, out loud and in writing, we create an internal memo the size of a billboard. This gives us a reference point against which we can assess our behavior. Every single thing we do will fall into one of two categories: does this behavior lead us closer to our intention or take us further away?

Add the ten-point scale to this, and at any one point in time you can determine where you are relative to anywhere you want to go. On a scale of one to ten, how close to my intention will this particular behavior bring me?

Declaring intent may be as imaginative, or as prosaic, as you wish.

Write the intent down on a piece of paper,
and hang it where you can see it.

Tell a close friend, and ask that person to ask you about it from time to time.

Make an "Intention Box," like an old-fashioned piggy bank,
with a slot where you can drop your intention after you have written it.

Write your intention in a letter. Then mail it to yourself.

Write the intention in a series of letters
and mail one a week to yourself, until the intention is realized.

Or
design a ritual,
like offering your written intention as a tasty morsel for the fire gods.

WHAT MATTERS?

When you get ready to write, it helps to think about the details ahead of time. That way, if you have any old habits of procrastination (fear!), you won't automatically fall into them. The best defense is offense, and not just for football. When you are tackling a job that you've avoided, or been confused about, paying attention to the details before you start matters.

Also. . .

The right *writing tools* matter.

Our brain processes writing differently depending on the medium we use. So handwriting is different from a manual typewriter, which is different from a computer keyboard, which is different from e-mail, which is different from transcribing a recording off an audiocassette. With poetry, I almost always start out writing by hand and then shift to a computer keyboard. Somehow, poetry thinking is connected to handwriting. With this book, it was keyboard from the beginning. With the keyboard, I feel like I'm having a conversation with someone rather than an internal dialogue with myself. It's a good idea to try out different tools and pay attention to how each one works for you.

If you write by hand, your implement matters. A pen, pencil, charcoal, crayon, calligraphy brush. If it makes a mark, you can use it. In the beginning, however, I suggest choosing what feels effortless as it slides across the paper. Something that doesn't draw attention to itself, that doesn't dominate the process, that doesn't distract your words from swimming across the page.

And *on what* will you write?

Lined paper?
Plain paper?
Bound paper or loose leaf?
Collected in a file folder? What color?
A roll of paper stretching out along the floor?
A leather bound journal?
A spiral notebook?

How precious do you want this process to be?

Like blue jeans and a plaid shirt, or silk velvet and crystal?
Only you know what gives you the most bang for your buck.

Do it.

How and *where* do you want to write?

Sitting up at a desk?
Outside on the ground?
Under a tree?
Sprawled on your living room rug?
Rocking in a rocking chair?
Curled up on the couch?
Sitting *on* the dining table? Next to your favorite plant?

Do it.

Where you write really, really matters.

Especially in the beginning, especially if writing is hard for you, especially if you put it off over and over again.

The environment should invite you to write. Play Bach, Mozart or Bruce Springsteen. Find a fragrance that enlivens you, like peppermint. Set a specific time for yourself, one hour is probably too short, three hours is probably too long. Make sure there are no interruptions. Turn off the phone. Put up DON'T DISTURB signs.

When you are ready to stop, use an old writer's trick: stop writing right in the middle of a sentence or a thought. Then, when you come back the next time, it's a cinch to dive right in.

When you write matters.

Choose your optimal thinking time. Some people think best in the early morning, some late at night. Almost no one thinks best in the late afternoon. (That's why the English invented four o'clock tea.)

Common sense says, forget writing after eating a big or heavy meal. I find that starchy foods—potatoes, breads, rice, pasta, sweets—knock my energy right out from under me. When I'm writing, I eat lots of big salads with toasted sunflower seeds and curried lentil stew.

Pay attention to yourself as you write. Sometimes slowing down gives the left brain a chance to catch up with the right brain. Other times, slowing down may be signaling a shift. When this happens to me, I try moving from the computer to handwriting or vice versa. If I'm handwriting, I switch from writing really, really big to writing really small, and back again. Or I turn the paper horizontally. Or I write diagonally, from corner to corner. These are all "wake up" techniques.

If none of these work, I know it's time to make a cup of hot chocolate and TAKE A BREAK. Lately I've been setting my alarm for a 20-minute catnap. Better than caffeine, I'm refreshed and ready to go for hours afterward.

The Writing Check List:

- Paper / computer / notebook / journal
- Pen / pencil / keyboard / typewriter
- Portable minute timer
- Pitcher of fresh water / glass
- *Crunchy nibble food: nuts, rice cakes, carrots, celery...
- Hallowed writing space
- Uninterrupted time
- A specific written intention for each writing session

*Research shows that crunchy, nutritious food increases our ability to concentrate.

WHAT'S TIME GOT TO DO WITH IT?

Timed writing exercises are wonderful tools. Writing fast eliminates cautious thought, the number one creativity killer. Creativity is a wild and splendid beast that does not fit well into careful cages. When you write fast, you ride the back of a racing panther, you feel the sensuous muscles carrying you through the undergrowth of your mind where a thousand undiscovered images wait for you to come crashing through.

Writing fast reduces internal censorship. When you write like the wind, you don't have time to get picky and start belittling yourself. You are too busy blowing yourself over mountain ranges into new territory—sailing over the Great Plains, over a blue-white glacier, into an old-growth forest dense with possibilities.

Writing fast trims away the excess. It pushes us to center on what is essential. When we write fast there is no time to sink into the swamp of our life, fiddle faddle about, drum our fingers. Writing fast pushes us up over the wall, never mind the height, the scratchy thorns, the heart dropping thud as we land on the other side.

Beat The Clock is a silly game. Be a kid. See how many words you can scribble down before the timer goes DING!

And remember: the great thing about writing is that, like an imperfect pot that a potter scraps, you can just crumple up the paper, hit the delete key and start again. Nothing is lost. Your writing muscles just get stronger with each mistake.

Dress Rehearsal

[Writing Exercise #3]

Here we go again:
Grab two or three pieces of writing paper. Or a notebook. Or a journal.
Grab a pencil or pen.
Or if you're feeling adventurous,
grab a huge sheet of paper and a chunk of charcoal,
maybe a crayon.

Get your timer.
Get ready to write *furiously fast* again.

Set your timer for THREE MINUTES.
Then, without thinking about spelling, grammar, punctuation,
or your Aunt Martha,
tell me about your work.

When the timer goes off: STOP.

You probably can't resist reading what you wrote,
but absolutely *do not* erase, edit,
or do anything to change it, since you will be using it later.

Now, stick this in the back of your writing folder; or if you are in a journal, turn the page and fasten it with a paper clip; or in a word processor, file the file. What is important here is *that* you wrote, not what you wrote. By the end of this book, you will have written so much that it will be amazing if you even remember that you started with this.

Before we begin writing in earnest, there's one, *critic*al detail to adjust.

CLEARING OUT THE CRITIC

Shutting up the insistent buzz of our inner critic is remarkably easy. Since it is we who have given this critic the authority to heckle us, it is we who can take it away. It is a matter of exercising our personal power, of *intending* to be in charge of our own writing process. This does not mean that we banish the critic forever, as delightful as that thought may be. A good critic, like a good editor, is sorely needed—*at the right time*.

The problem begins when we forget that the internal critic is supposed to be in service to our writing, and not the other way around. Taking charge of your own writing may put you through some deep-sea bends, while you adjust to the pressure, but the satisfaction of writing without the editor/critic is well worth the effort. It is truly amazing how different it is to write without the critic's boot pinning you down. Just holding a pen becomes a state of grace.

How do we do this?
With a simple, guided visualization.
In the last few decades, guided visualizations have been remarkably effective in a number of circumstances, from reducing critical pain to erasing annoying habits. In the seventies, the Russians set up three case studies with their renowned athletes: 1) athletes who physically practiced, 2) athletes who combined physical practice with visualizing themselves practicing, and 3) athletes who just visualized themselves practicing. The amazing thing was not that the [#]2 group outshone everyone else, which it did, but that the [#]3 group performed as well as the [#]1.

Visualization exercises create an internal experience that can influence how well you write your artist statement. In Visualization Exercise $^{\#}$1, we are going for damage control by setting up clear boundaries and roles for your inner critic.

Start by sitting comfortably and upright, so you can stay alert, with as few distractions as possible. This visualization is simple enough to read once and then do by yourself.

It is also a treat to have a buddy read it to you, so you are free to drop into the experience. Either way, clearing out the critic shakes out the inner static and lets you tune into the crystal clear signals of your writing mind.

VISUALIZATION EXERCISE #1

Close your eyes and imagine your internal critic. Who appears on the scene when you have to write? For me, it is my eighth grade English teacher, with her rigid back and her equally rigid relationship to language.

With your eyes still closed, imagine your internal critic in Technicolor. Notice the way your critic stands and looks at you, how your critic is dressed, what the body language signals. Then, firmly, authoritatively, but respectfully, give your internal critic its marching orders.

Carefully explain—ignore sputtering and interruptions—that you will be writing and that the critic may help later with editing, but right now the critic must (no choice!) leave the room and find something else to do. Explain that the critic's role is not in the writing circle, but in the editing circle. This is not banishment, this is a changing of the guards. The critic gets to take a much-deserved break from all that looking over your shoulder.

Still with eyes closed, escort your critic out of the room and set the critic up somewhere else, with crayons or clay. Or send it out to climb a tree, or go on a picnic, or visit a museum...*whatever* (just be very specific).

Come back into the room and slowly open your eyes. Feel what the space is like with only you in it.

Enjoy the momentary peace and calm, but be watchful. Your job is to stay awake and catch the critic sneaking back in to whisper that you are not good enough, or smart enough, or honorable enough to do this good work. As with any willful child, you will, periodically, have to escort your critic back to its activity. This is a new relationship, and no self-respecting critic easily gives up the Throne of Judgment.

This exercise is good any time you set about to write anything. It only takes a couple of minutes to effectively rein in this judgmental part of yourself by setting up internal boundaries. It is also fascinating to watch how the critic responds, over time, and how other areas of your life benefit.

Revealing The True Spirit Of Your Work

The Perfect Place To Write

[Visualization Exercise #2]
[Writing Exercise #4]

Everyone deserves the perfect place to write. Even you. *Especially you.* This guided visualization gives you permission to imagine your most perfect writing place, no *ands*, *buts*, or *maybes*.

As before, sit comfortably but alert. Place paper and pen/cil close by, so you can easily reach out for them. This visualization is also great with a friend leading you through it.

Close your eyes and imagine that you are standing in front of a door. On the other side of this door is the perfect place to write. When you open the door and step through you could be outside under a grove of white birches with the wind shimmering through a thousand leaves, or in a room with wine-velvet chairs and gilded notebooks gracing an oak desk in front of a fireplace.

Take three deep breaths and slowly let them out. Now, reach out and take hold of the door handle—how does it feel in your hand? Smooth? Cool? Is it shiny brass, or a crystal knob? Slowly open the door and step into your perfect writing space.

Look around. Where is the light coming from? How does the air feel against your face? What smells float through the air? Where are you and what is around you?

Inside your perfect writing space, find a place to sit that is supremely comfortable, yet keeps you alert. Settle down there. Close your eyes. Travel into a place inside yourself that is very, very kind. Maybe it is your heart, or your hands, or your solar plexus, any space inside your body where you feel kindness living.

Touch the kindness with your mind. Feel it spreading out like a light, radiating out until it fills up your whole body, travels out and down your arm, into your writing hand.

Inside your perfect writing place, open your eyes and pick up a pen or pencil or quill, whatever writing instrument you want, and write down anything that comes to you, anything at all.

Slowly, come back and open your eyes.

Write down what came to you in the visualization.

File it away.

Crafting an artist statement can be traumatic. Sometimes, just thinking about writing an artist statement is unnerving. But creating your art and writing an artist statement are kindred activities. In both cases, you work with raw materials, a commitment to set aside time, patience with yourself, and lots of practice. You did not learn to throw a pot, stretch a canvas, weld metal, or sew a tapestry in one sitting; nor will you learn to write an artist statement in one sitting. But when that first statement sits gleaming in your hand, your deep satisfaction will be the same.

The next six chapters are all writing exercises, so you will want to be set up to write.

You will need a minimum of:

Paper, pen/cil, timer,
and a sense of how long you will be able to hang in here.

(For a complete set-up, see the Writing Check List on page 86)

JUST DO IT, RIGHT?

[Writing Exercise #5]

Roll up your sleeves and get ready to pump words. The idea is to carve out definition for your language muscles. Flabby sentences, loose points of view, language love handles will soon buckle under a new regime of exercise! Exercise! Exercise!

Which reminds me, when you are writing, as with any sedentary process, short, hard bursts of physical exercise keep you going. Fifteen minutes of very fast walking (you spend more time with the refrigerator door open) gives you hanging-in-there will power. Coffee and doughnuts—*Oh! Darn!*—do not.

From now on, I want you to suspend
self-doubt
and
second guessing

suspend judgment
on
what you are thinking
and
what you are writing.

I want you to give yourself permission to write horribly,
the worst of the worst,
to say *whatever* it is you *really* want to say.

This is for no one else but you,
so in this moment
anything goes, *anything*.

Close your eyes and imagine that all of your current pieces are being shown in the gallery or
museum of your dreams, and a favorite relative has just come to see your work. S/he loves what
you do, but wants to know more. What do you want to tell her/him about your work?
When you are ready, open your eyes.
Set the timer for THREE minutes.
Write *fast*,
without caring about complete sentences
or the sink full of dirty dishes.

Write like you dream,
half phrases, absurd imagery,
anything at all.

When the timer DINGS, stop! File it away.

JUST DO IT, LEFT

One of my favorite T-shirts says: *Only left-handed people are in their right minds*. For the rest of us, who are left right behind, there is a remedy: non-dominant handwriting.

The theory is that the hand we use for writing, called our "dominant" hand, represents the dominant side of our personalities. Assuming that we all have many parts to our personalities, some parts get more airtime than others. Some have a "voice," and others do not. The ones with access to our dominant hand get to speak the loudest and longest.

On the face of it, this does not look like a problem. Mono-self seems to work just fine, most of the time. Unless, of course, there are non-dominant parts of our personalities that have something valuable to contribute, but no way to reach us.

I suspect that the still, inner voice we call "intuition" is an attempt by the "quiet ones" to be heard above the roar of our disbelief in the different parts of ourselves, in part because it sounds too much like "multiple personalities," and who would want those? But what if we all consist of multiple personalities? What if, as we grow and develop very different aspects of our personality, these are seamlessly integrated into our whole self, and only under the shock of extreme trauma break apart and start operating autonomously and without connection?

What if we are a far more complex and dynamic constellation than the mono-self culture would have us believe? If this were the case, what could we learn? What wisdom and insights might await us if the silent ones within us could speak?

Non-dominant handwriting is a fairly simple, straightforward process. You ask a question with your dominant writing hand and then hand over the pen/cil to the non-dominant hand to write the answer.

At first, the whole thing feels awkward and a bit silly. For one thing, your writing becomes almost illegible when you shift hands. Sometimes it's a good idea to immediately write in a "translation" with your dominant hand above certain words, so you can read them later on.

Sometimes you will have an odd sense that you know, beforehand, what your non-dominant hand is going to write. Most of the time, you don't, and the words will come out quite differently than imagined. It is a curious sensation to have the "right" thought come out entirely different on paper.

Then, there is the sense that someone else is writing, which can make you feel a bit crazy. Unless, of course, you become so enchanted with the delight and surprise of what your non-dominant hand is saying that all of your reservations fall away. All I can say is, test it out for yourself. Try it a few times. You may have an entire kingdom of wisdom and insight waiting for you just a pencil mark away.

WRITING, WRITING, WRITING

[Exercises #6, #7, #8, #9]

Engaging your ability to write an artist statement is for the long haul. Each time we shift in our development as artists we will need an artist statement that shifts with us. This is not as daunting as it might sound. For one thing, as long as we create art, we will be simultaneously creating word-thoughts about our art. As creatures of language this is inescapable.

The trick is to catch ourselves, to tap into the natural language of our minds; for we are the only ones who can tell *what*, *how*, and *why* we do the work we do. And, as our work grows and changes, so will the word-thoughts that accompany its unfolding.

One way to capture the words about your work, which *you already have*, is to unplug the self-consciousness that comes when you try to write about yourself. We have been conditioned, in so many ways, to feel awkward saying anything complimentary about ourselves. Conversely, our culture encourages us to make demeaning, belittling self-comments, especially under the guise of humor.

The following writing exercises use fantasy to trick the Matron of Disapproval into looking the other way. They also replace self-consciousness with the playfulness of magic, memory and mystery.

As you begin to write, remember what Natalie Goldberg tells us in *Writing Down the Bones*: allow yourself to be awkward. It's the beginner's way. In the beginning, anything goes. You fall down, you get up, you keep writing, writing, writing. More is better. And *anything goes!*

You are the fisherman casting your net into the sea, never knowing what will come up. You may catch a squid, or a mermaid who grants three wishes. But in the end, just be grateful to life for the absolute perfection of any small shell.

Treat these next three exercises like cookies for your creative spirit. Nibble one at a time, over a few days. Or gobble them up all at once.

Timed Exercise [#]6:

With your eyes closed, imagine that you are in your studio when, suddenly, one of your pieces starts to talk to you.

- Write down everything this piece says to you.
- No matter how absurd, just keep your hand moving.
- Set the timer for THREE MINUTES

** Again, don't worry about spelling, punctuation or even complete sentences. This is where you get to flow with whatever, even if it's the same two words over and over again for a whole page. You can always come back and do these exercises again, as many times as you wish.*

TIMED EXERCISE [#]7:

Your best friend from childhood, whom you have not seen for a long time, comes into your studio while you are working. Close your eyes and see this person standing there, waiting to be invited in.

- What do you want to tell this person about your work?
- Set the timer for THREE MINUTES
- Write like one possessed. So much to tell; so little time.

TIMED EXERCISE [#]8:

Close your eyes and watch a piece of your work come to life in the studio. What does it *do*?

- •Write this one for the child in you, the one who loves magic and being silly.
- • Set the timer for TWO MINUTES.
- • Ignore any jaded adult reactions.

Now, go back and try all three writing exercises with your non-dominant hand, i.e., if you normally write right-handed, switch to the left; if left-handed, switch to the right.

How do you feel after this writing extravaganza? Elated? In a creative zone? Or wilted, like someone who has stayed out in the sun for too long? Don't judge yourself. Just notice where you are and what it was like to write like this.

Stash these uncut gems away for now, and finish up with one more exercise.

TIMED EXERCISE [#]9:

How do you feel right now, this very minute, about the writing you just did? There is no right answer, only the real one.

- Set the time for TWO MINUTES.
- Write it out, gut honest, and then let it go and move on.

CLIMBING OUT OF THE BOX

[Writing Exercise #10]

This next exercise is an old creativity pumper-upper called "random associations." It pulls you out of your usual thinking patterns, gets you out of your own, cozy thinking box.

Fold a lined sheet of writing paper down the middle. On one folded side, at the top, write one of the following words, whichever appeals to you at this moment.

Octopus
Barn
Snowstorm
Candle
Beach
Pasta
Rose
Moon

Set your timer for *two minutes* and list as many characteristics of that word as you can before the *ding*!
Turn the folded paper over and on the opposite side, at the top,
write down a title or short description of a recent piece of your work.
Set your timer for *two minutes* and list, on this side,
as many characteristics that describe your work, as you can, before the *ding*!
Now, unfold the paper and see if you can find any random associations between the descriptions on the left and the ones on the right. Are there connections here that could describe your art in a new, but relevant, way?
Write a third list of descriptions for your work, which includes the new ones from this exercise. Do this as many times as you want by choosing another word from the list. Or, make up your own list of random words to choose from.
Put these exercises into your gathering folder for later.

If you have already taken a break from reading the book and gathered material for your artist statement, then continue on.

If not, go back to Chapter 24, TAKE A BREAK, and follow the gathering instructions for as long as you want, before doing the next round of exercises. The reason: the next series of exercises will be using the variety of ideas you have been, or will be, collecting.

THE INTERVIEW

[Partner Work]

This exercise is ideal with another artist who is also working on an artist statement, so you can trade off. If not, anyone who is willing to be your secretary for half an hour will work just as well.

Your "secretary" will interview you with the following questions and write down your words. If you want, tape the session so you can listen to it later. Before you start, be sure you both read the interviewing suggestions:

For the Interviewer:
1. Give the interviewee time to think before answering.
2. If a question doesn't work, move on and come back to it at the end.
3. Let the interviewee wander off the question path. If the question hasn't been answered at the end, ask it again.
4. Only interrupt the person you are interviewing for clarification, or to repeat what they said.
5. Resist correcting or editing the person you are interviewing, or cutting them off.
6. Write verbatim, but leave out the *ums* and *ohs* and *like ah*.
7. Print, if you are unsure of how legible your handwriting is.

For the Interviewee:
1. Speak slowly, take your time.
2. Keep it short, you can add things later.
3. Try not to repeat yourself.

Interview Questions:

1. What is currently exciting to you about your work?

2. How do you approach your work?

3. What's the philosophical or emotional base you work off of?

4. What stimulates ideas for you?

5. What materials do you use? Why these and not something else?

CLUSTERING

The clustering technique will kick-start the first draft of your artist statement. Before beginning this exercise, read the chapter all the way through. Then come back and follow the instructions.

You will need:
- All, and I do mean *all*, the writing you have done since beginning this book
- Photocopies of original pages, which you do not want to mark up
- A highlighter pen
- Felt tip markers with medium tips in several different colors
- A very large piece of paper, roughly 30 by 48 inches
- A notebook, or single sheets of writing paper
- Your writing pen/cil
- A good chunk of time: at least 90 minutes

Pull out all of the writing exercises, your gathering notebook, and anything else you have written about your art since starting this book. Grab a highlighter and highlight every single phrase or word that strikes your heart-mind. If you don't want to mark up your originals, first photocopy the pages you wish to highlight.

Clustering is a right brain, learning technique pioneered in the 1970s by Tony Buzan in *Using Both Sides of Your Brain*. Instead of using linear outlines and sequential data, he theorized that learning works best when we organize material the same way the brain organizes information, with neural pathways branching off of central points. The idea caught on, and now we don't think twice about dividing learning strategies into right and left-brain styles. Clustering has also been called spider webbing or mapping, and is often used to order ideas generated in a brainstorming session.

The Clustering:
Draw a small circle in the center of the large paper and inside write "artist statement." Next draw one line, like a spoke off of a wheel, from the center circle out. Look at your highlighted phrases and choose one. Write it on that line. Look at another highlighted word/phrase and decide if it is connected to the word you just wrote on that first line, or if it is an entirely new thought. If it's new, draw another line off the center circle and write that word on it. If it's related to the first word/phrase you put down, draw a line off of that line and add the word/phrase.

Work your way through all of your writing, selecting phrases and words to "cluster" around your center circle. Make sure you connect thoughts which are alike to the same line by branching off with more lines, like the branches and twigs of a tree.

CLUSTERING DIAGRAM

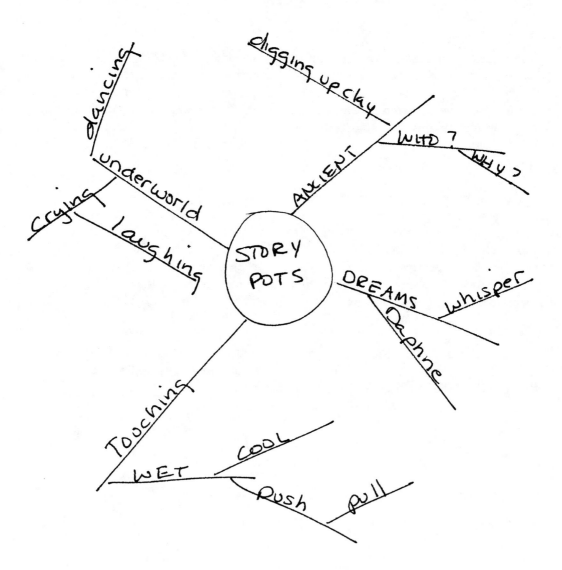

CLUSTERING BRANCH
[Close-up from the clustering diagram.]

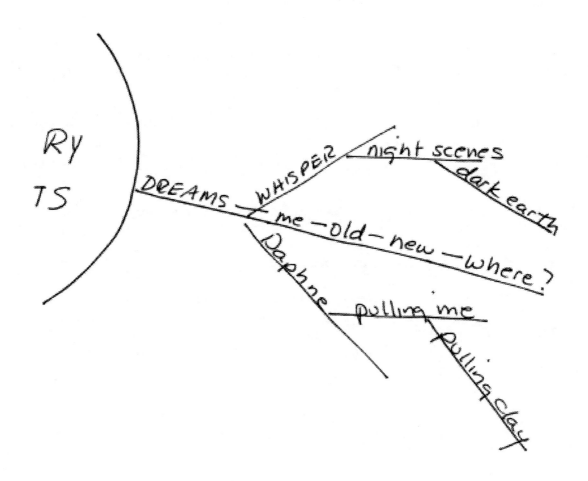

RY
TS

DREAMS — WHISPER — night scenes — dark earth

me — old — new — where?

Daphne — pulling me — pulling clay

Revealing The True Spirit Of Your Work

The shift:

At some point, as you are clustering, you will experience a shift in your awareness. It is as if the clustering fragments fill up the right brain with enough material so that ideas finally flow over into the left brain and the words and phrases shift into coherent thoughts.

When this happens, begin writing down these thoughts for as long as the flow continues. This will be your first draft of the artist statement. If the river dries up, but the first draft is not finished, go back to clustering until you experience another "shift." Do this until you have completed a satisfactory first draft of your statement.

You can also *cluster, shift, and write* as many different drafts as you wish. In the beginning, you can never write too much, since it is easier to toss out than dredge up. Also, since you may have a use for several different artist statements related to different pieces, different shows, or different times, hanging onto everything you write makes sense.

Once you have a satisfactory rough draft, you can begin tinkering with the details. Because an artist statement is compact, each word really, really matters.

TRICKS OF THE TRADE

Here are a few writing tricks, which you can play with. Take your first draft and see how many of the following you can incorporate into your statement:

• Replace general statements with specific details. "I like oil paints," becomes, "I like the way oil paint smells, a bit forbidden, like sniffing glue. I like the wet look of it slipping off my brush and onto the canvas."

• Use as many of the senses as you can: sight, sound, smell, texture/touch, taste. These hook a reader by exciting primal areas of the imagination.

• Try repetition: *This goes to the heart, this goes to the spirit, this goes to the soul....*

• Use variation on a pattern: *of the people, for the people, by the people...*

• Link the beginning to the end by repeating a phrase, a word, or a sentiment that shows up in your first paragraph.

Writers also create dynamic tension to keep a reader engaged. Try some of the following:

- Connect contrary images, senses, or ideas: *It is the shock of soft leather against my callused fingertips that calls me to sorrow.*

- Paradox generates surprise: *I love the dark light that pours from my prints.*

- Polarity posits extremes from a single continuum: *I inhale inspiration and exhale the mandala.* Other polarities might be: day/night, waxing/waning, create/destroy, etc.

A Few Questions To Consider

Have you covered:
What you do...
How you do it...
Why you do it...?

Notice the tone of your piece. Is it quiet and simple? Bold and brash? Sophisticated and elegant? Is it earthy and grounded? Ethereal and wispy? Is it wide and flowing? Or narrow and steep?

Does this tone reflect the tone of your artwork? Do you keep the same tone of voice throughout, or does it shift at some point? Is this shift jarring or smooth?

Next, read your artist statement out loud. Notice, and mark, any passages where you feel as if you just tripped over a tree root. It might be a word out of place, or an image that pulls you out of a specific mood.

Are you ready to revise?
Rewrite?
Call your critic back in to help edit?

COOLING DOWN
IN THREE PARTS:

AFTERMATH

DON'T STOP NOW

MARKETING

Revealing The True Spirit Of Your Work

PART ONE:

AFTERMATH

PATIENCE, PATIENCE, PATIENCE

The first draft of an artist statement is love at first sight. The honeymoon. You and your baby. At this stage, you can't get enough of your own unabashed brilliance.

Or, the first draft may be the reincarnation of every fear that you've ever had about yourself and your art, and you're ready to sign up for the Marines.

Either way, it's a good idea to stick the first draft in a drawer for a couple of weeks, or longer. Don't look at it. Don't tinker with it. Don't flush it down the toilet. And especially, *don't think about it.* Immerse yourself in something else until you can honestly say, "Artist statement? What's that?"

The initial, rosy glow of creation (or the self-fulfilled prophecy of doom) makes it hard, if not impossible, to toss out, reshape, and fine-tune your statement into a condensed masterpiece of compelling writing. Time loosens the birthing bond (or the fear bond), giving you enough distance to make the right decisions about what to keep, what to toss, and what to change. Obviously, weeks of retirement won't work if a deadline is staring you in the face. In that case, put the first draft away for at least a few hours, or a day, before attempting any revision.

REVISING

Re-vision—or second sight—is like looking at your kitchen after a smashing dinner party. Time to roll up your sleeves and do the dishes. It may not beat out sex, drugs and rock 'n roll, but I guarantee that a spit and polished draft will be worth every ounce of patience it took you to get there.

Assessing The Writing

Writing is a process, a verb. Writing is alive, changing as you change. Writing does not lock you in. Don't like a word? Erase it.

Conversely, what happens to that fantastic sentence you like too much to pull out, but every time you read your statement, you trip over it? Taking it out doesn't mean you have to give it up. Stash your gem in a file for future consideration. Over the years, I've established a large, literary orphanage for my homeless words, all waiting for the perfect story-parents to show up and adopt them.

This next section may be a bit much to tackle in one sitting, so don't hesitate to break it up into a series of mini-revisions.

Look over your statement and ask yourself the following questions:

• Does each word do its job? Check out key words and ask: *What does this word reveal?* What is its tone (high-pitched, low, somber, bright, smooth, rough, spicy, bland)? Ask if that tone resonates with the rest of your statement, and especially with your artwork.

• Do the same for each sentence. Ask, *what role does this sentence play?* If this is a key sentence, what does it convey? What is the tone? Does it add to, or take away from, the overall feeling I want my statement to project?

• Look over key words and make sure that their "private" meaning is obvious. If you are not sure, ask two other people to read it and tell you what they think a word or phrase means. Sometimes private meanings are so obvious to us, we mistakenly assume other people will get it, too.

• Look at your overall style of writing. Are you a long-sentence person or a short-sentence person? It works best to mix up the length of sentences so readers aren't lulled into a rhythm that ends up zoning them out.

• Do you use metaphors? Metaphors are the magic carpet of language, where we can lean over the side and see the mountains and valleys and savannas of meaning, all at the same time. But select metaphors with an eye to less, not more. Like a seductively rich chocolate desert, a few bites can often be enough.

• Is there a logic that moves the reader from one sentence to the next? One paragraph to the next?

• Is there a theme or thread that ties the whole piece together? Like moving from a childhood memory to the present day. Or using nature images throughout. Or dropping in colors as the basic beat. Or weaving in a story about your grandfather and your art from beginning to end.

• Have you trimmed your words to the absolute essential? Always, always remember that, for an artist statement, *fewer words create greater impact*. Keep the final version to three or four paragraphs, with no more than five or six sentences in each paragraph. At the most, stick with a single page. So, take a deep breath and eliminate words that are:

- Unfamiliar to your audience

- Reduce your reader's comprehension

- Add unnecessary complexity or confusion

Here is a list of DON'TS that come directly from gallery owners. These were the mistakes they saw over and over again in the artist statements that blew through their doors:

- Poor writing quality. (Get help!)
- Writing way too much.
- Using overblown phrases.
- Using incomprehensible language.
- Using grandiose generalities that say nothing.
- Making evaluative comments about the work.
- Trying to convince the viewer that a piece is doing X or Y.
- Focusing on the artist's psyche, to the exclusion of the art.
- Focusing on technical aspects, to the exclusion of anything personal.
- Telling the viewer how they, the artists, want their work to be viewed.
- Stating the obvious about the work, with no additional illumination, i.e., I paint on canvas.
- Trying to convince the viewer of something which is not evident in the work.

The most damning mistakes happened when artists brought in mediocre work, and then expected their artist statement to carry the day. All the fine words, exotic language, and magnificent feelings of an artist don't matter one whit if the work does not hold its own.

Yes, it gets tricky when some artists assume that they are achieving something with their work, which they are not. The lesson here is, *check it out.* Take your work and your artist statement to three people: a friend who knows you well, a local gallery owner, and an artist you respect. Ask them if the statement and your work are simpatico. Feedback is invaluable, especially if two or three of these people have the same responses. You may not accept all that they say, but at least it will expand your perspective and perhaps keep you from accumulating too much egg on your face.

Other Times, Other Ways

Artist statements come in a variety of sizes. The one-size-fits-all is what we have addressed thus far. There are three other places where an artist statement is needed, but with modifications. For any of these, the writing exercises outlined for the general artist statement work equally well.

The first is the *Art Statement*.

Sometimes a specific work of art, often a large, commissioned, or installment piece, needs a statement of its own. What is it? What does it stand for? How was it made? The best Art Statement incorporates a philosophical, social, or aesthetic perspective, along with some illumination about the history of the piece, the techniques used, and the artist's personal relationship to the particular work. These statements can range from a single page to a series of pages that follow each section of the work.

The second is the *Artist Statement as Infomercial*.

These are usually associated with crafts in the retail sector. Most often, one zippy little paragraph (or two very short ones) needs to combine a smattering of the personal, along with techniques used and customer care information.

The third is *Application Statements*.

These are required for any number of art-related ventures: teaching positions, admittance to art schools, grants, artist-in-residence positions, juried shows, art festivals, etc. Here the most critical issue is, *read the instructions*. Of course, you are just asking for trouble any time you restrict creative people with directions, instructions, or rules. But, this is one place where an artist who remains chained to individualism and the right of self-expression shoots himself in the foot.

You would be surprised at how many otherwise intelligent people (and perhaps, intelligence is the real dilemma here) ignore the details outlined in an application form. If they ask for one page, don't give 'em two, or one-half. Give them one page, no matter how much teeth-gnashing it causes.

Keep your eye on the prize, and reserve rebellious impulses for your art. When a committee is staring down a pile of 200+ applications, trust me, they don't give a hoot for your brilliance or your creativity. If you are No. 122, and there's a technical slip-up ... whew! One less application to read. Chances are, in that pile, there is more than enough brilliance to accomplish their mandate *sans* you. Don't give them such an easy out. In fact, use the limitations they impose as a challenge. How creative can you be *inside* their box?

Finally, consider working up *Multiple Artist Statements*. For some artists, the complexity of their work calls out for a range of statements for all seasons. One artist I know hired a writer to come up with 20 different statements. You might consider two or three, especially if you have too much to say for one.

PRESENTATION IS *ALMOST* EVERYTHING

You have written your statement, now it's time to put it in front of your audience. Here's where paying attention to detail continues to pay a handsome return. Remember, every single presentation detail builds a cumulative aura, a signature of style, which lingers around your work, whether you want it to or not. Neglecting details, in the hope that their absence will get you off the hook, does not work, for absences, like silences, carry their own message, a message that is much more difficult to influence and direct than the details you tried to avoid.

If you take the time to present the "mundane" details in your unique signature, the overall imprint of your presentation will be that much stronger, more powerful, and more memorable. Especially today, when we are all shell-shocked from commercial, aesthetic bombardment, your audience needs all the help you can give it to appreciate what you do.

There are several ways to format and display your artist statement. It may be part of an artist brochure, or you can print it on business card stock and set it in a rack for viewers to pick up. If you are in a gallery or a show, be sure to print and mount your artist statement on a wall next to your work. I suggest doing all three presentations, because *repetition is the key to recognition*. Since your art is the obvious calling card, you have to make an extra effort to keep your name equally in front of the viewers. One way is to include your contact information on everything your patrons could take home with them.

One artist I know sets her statement, printed in a large format with a tasteful border, on an easel beside her work. Her own mini-billboard. It never fails to attract an audience, who invariably reads every delicious word before looking at her work. You can almost see the *aha* light of recognition in people's eyes, as what they see matches up with what they have just read. And to make sure they don't forget her, she prints the same statement on small business cards for people to take with them, whether or not they buy a piece of her work.

The individual Art Statement is most striking when you print it out large enough to easily read from three feet away, or over someone else's head, and mount it inside a handsome frame to hang near the piece. Then, for your patrons, print out smaller, identical versions with contact information, one or two lines of biography, and a mention of "accepting commissions," printed on the reverse side. Even if it ends up in a wastebasket, chances are it was read one last time and your name imprinted one more time on that person's mind.

Side note: If you are going to include a visual image of the piece, make sure it is spectacular. A poor visual reproduction hurts your work more than it helps. If you don't want to, that's okay, too. People's imaginations have a way of magnifying what they remember, so you're in good shape either way.

For the artist statement as infomercial, print it on business card stock and send it, with a Plexiglas business card holder, to the retailer. Include instructions on how to display the cards near your work. Or find a way to attach, or mount, one card to each individual piece. One craftsperson I know slips her statement, which also contains her contact information, inside each pot, as well as displaying it next to the pots. This way, she knows that the information travels home with every piece.

In all cases, you will do yourself a great service to hire a graphic designer, someone trained to lay out words with a unifying graphic, who knows how to select the right typeface, the right paper, and the right colors. This step can be hard for some artists, who may think they have a corner on aesthetics and why should they hire someone else's visual expertise?

But, even though graphic design comes from the same jungle, it is a different beast altogether. And why take the time to tame it? Better to spend the time on your own art, and let someone else do this faster, better and certainly with less aggravation than you could.

What's most important is finding a graphic designer who has actually studied graphic design. Software, plus a room full of computer gadgets, may give the illusion of competence and professionalism, but it is absolutely worthless when it comes to a good sense of design. This is one area for which the term, "garbage in/garbage out," was invented. You'd be surprised at how a simple detail, like selecting the perfect typeface to compliment your work, can raise your presentation to the next level.

PART TWO:

DON'T STOP NOW

Revealing The True Spirit Of Your Work

TAKING THE LONG VIEW

In some ways, artist statements work off of a class system. When you are on the bottom rung of the ladder just starting out, an artist statement is an essential part of your professional portfolio. Once you have "arrived," then words around your art are taken over by others: the purveyors, the critics, the collectors, the audience. At this middle stage of professional development, artists usually no longer own the words around their art, nor are they often asked to provide them. Artists give up this privilege, which many of them never wanted or claimed in the first place, and turn the power of words over to others, who, in turn, shape the public's perception.

Even though this is the way it is, I strongly suggest that artists keep pace with what others are saying and writing, and consistently put their own words out with their art again, and again, and again—at all stages of their careers, if for no other reason than to provide an invaluable contrast between the perspective of the viewer and the perspective of the artist.

Also, should you end up an art legend, your words will be sought out once again. People absolutely crave to know what famous artists think about their own work, how different pieces came to be created, what the story is behind the art. Even if fame is elusive, consider the historical value for friends and family of having a trail of your own thoughts following the path of your life as an artist. You never know: future historians may love you for it.

KEEPING THE FLAME ALIVE

Since writing the artist statement, like doing your art, is a long-term partnership, you'll do best if you blow on the embers on a semi-regular basis. Here are four strategies for doing just that.

Keeping Up With Yourself

The very best suggestion I can make is *keep a journal.* It does not have to be elaborate, unless that's your style. A painter I know used to keep large journals about her relationship to her art, which she wrote in for years. Then fibromyalgia hit and quite a few things in her life just fell off a cliff. Journal-keeping was one of these. It was also one of the things she missed the most, besides painting. She stayed away, in part, because those large, impressive journals of yesteryear were big and heavy and intimidating for a body that could barely put one foot in front of the other. She thought that she had to give up journaling until she discovered a small, spiral notebook that fit perfectly in her pocket. She relinquished her old expectations. Instead of grand sentences, she settled for jotting down partial thoughts, fragments, pieces as small as small could be. And, it was just right.

Wanna Learn? Teach.

Nothing ratchets up the learning curve, or puts procrastination in its place, like preparing to teach something. Perhaps there's a high school art class you could go speak to about writing the artist statement. Or find a precocious art student in your local community college who would like to learn more about putting together a portfolio. Or think about a class you could give at the local YMCA. All the exercises you would need, in their developmentally appropriate sequence, are here in this book. Teaching and art are kindred traditions. Teaching serious artists how to write an artist statement is a small, manageable beginning. Who knows, you may even love it.

The Buddy System

Find another artist who also needs to shape up her artist statement and work on it together. This system works for the simple reason that it is easier to stay committed to a journey when someone else comes along. It is also more fun, as long as you don't take too many side trips and forget where you were going. This book is a good map for the buddy system, since a number of the exercises work best with two people trading off.

Group Support

Like the Buddy System, the nature of a group demands a certain amount of commitment and consistency, both of which help you get your artist statement written. And as far as I'm concerned, you can never have too many brains hanging around the country store. Other things may prove troublesome, things which often come attached to brains, like egos or personality twitches. But extra brainpower just means more ideas, more perspectives, more possible ways of getting whatever you want just right. The trick is to take what you want and *kindly* ignore what you don't. When you don't like another person's idea, it helps to preface it with, "That's an interesting suggestion. I'll think about how it might work," don't blink, and then move right along.

PART THREE:

MARKETING

SOILING OUR HANDS WITH THE BUSINESS OF ART

In the 1940s, my parents started an artist colony in Big Sur, California with Henry Miller. One of their favorite pastimes was to have grand, intellectual conversations about art and life over dinner and a good wine. The prevailing myth of the day was that great art did not soil its hands with money. If money from your art came to you unexpectedly or unplanned, great! But to deliberately try to make money from your art smacked of selling out and artistic compromise.

However–lofty, idealistic principles notwithstanding-you still had to eat. No one knew this better than Henry Miller, ensconced in his-Partington Ridge cabin in 1944 with no electricity, no telephone, no running water, no car, and 50 miles from the nearest town, Carmel. During this time, Henry's work lacked the stellar audience it would garner later on, and Henry was hungry. Light bulb! He wrote what we would now call a fund-raising letter. Then, it was simply a plea to absolutely everyone he knew around the world. If they would send him a ten spot, he would send out one of his watercolors. Marketing, public relations, fund-raising, he did it all. And no one ever hinted that any of this would compromise his art. In fact, his argument was that hunger compromised art.

If you want your work to be seen by a wider audience than Aunt Martha and cousin Lil, there comes a time when you have to be willing to make that happen. It takes time, patience and the willingness to keep getting back up again, and again, and again. Besides the competency of your work, it takes paying attention to the details that will put your art into the world, or if you have the means (or learn to barter), finding someone else who can do this for you.

Know Your Audience

The cornerstone of all smart marketing strategies, which holds equally true for artists, is: *know your audience*. Each gallery owner, or other venue, has a different idea of what an artist statement is; where, or if, they will use one; what form they would like the statement to be in; and what distinguishes a fine artist statement from a mediocre one. One of the oldest mistakes in the book is for an artist to send out portfolio material without researching the guidelines. It is a lazy mistake, extremely inconsiderate and self-centered, and tags any artist, no matter how good the art, as unprofessional.

In the case of a gallery/craft retail store, where the art is highly functional—bowls, tiles, cookware, jewelry, etc.—an artist statement is a blatant marketing tool. Like the tags we find on designer clothes, reminding us that a flawed fabric is really okay, the tags we find on a $200 platter reminds us that: "I live in the Berkshires. My studio overlooks the trees. I'm influenced by nature. You can put this platter in the microwave, in the dishwasher, don't put it in the oven." The typical customer does not care where these craft/artists went to school, whom they studied with or what kind of degrees they might have.

In the case of galleries and museums, each place will have a slightly different take on the artist statement. Many places won't care about the specifics of your presentation, as long as it is done with care and attention to professional details. For others, the gallery or museum may have something very specific in mind, and when you are just establishing a connection, it is a good idea to both ask and deliver what they want.

Revealing The True Spirit Of Your Work

DEALING WITH OUTSIDE RESISTANCE

A well-written, well-presented artist statement marks the artist as a mature professional. The fact that you took the time to write a statement shows a gallery owner several things at once:
- You are committed to your work.
- You are able to think beyond the scope of making art to larger issues surrounding your work.
- Your attention to detail portends reliability. When a gallery runs out of your work, they want to know you'll produce more for them in a heartbeat.
- You care about connecting to a potential audience of collectors, upon which you and the gallery depend.

However, not all gallery owners understand the full extent of benefits that an artist statement can offer everyone involved. While querying a gallery about their policies regarding artist statements, you are likely to receive a range of responses, from *yes, all the time* to *no, seldom* and *it's not critical.*

In fact, some gallery owners actually head in the opposite direction, *never.* This may be based upon a pragmatic philosophy, like one gallery owner who believed that written artist statements were detrimental to the highly personal approach he took, training gallery attendants to become the knowledgeable liaisons between his artists and his patrons.

Other gallery owners may seriously believe that a statement is unnecessary because the work must be able to stand on its own, as if one had anything to do with the other.

Often, resistance is simply because gallery owners meet their artists in person, and this precludes their need for a written connection. Since they do not need a bridge between the work and the artist, they inadvertently transpose their experience upon the people coming into the gallery who do not have this personal advantage.

Sometimes the most recalcitrant responses—*no, absolutely not*—are based on well-founded fears. Over the years, these gallery owners have seen a bushel of poorly written, overblown, pompous, esoteric, inauthentic, and just plain scraggly artist statements.

If you get a negative response, dig a little and find out what is behind their resistance. If someone is worried about ineptness, suggest that you send a statement and they can give you feedback. If a gallery doesn't use statements because they have personal liaisons between the gallery and the artist, suggest that you prepare a statement formatted for the patrons to take home with them *after* they have spoken with the gallery's knowledgeable attendants, or for background, or promotional material for the gallery.

For some gallery owners, the artist statement is inconsequential. These owners, sometimes artists themselves, respond more to visual language than to the written word. "I never look at the artist statement," one owner told me. "The art I pick is self-explanatory. I don't want to hear about it in words." This owner makes the very human mistake of assuming that everyone who comes into her gallery is just like her. Also, she does not understand that a good artist statement does not "explain" the work, but increases connection and bonding to the work.

In all of these cases, artists would do well to go ahead and prepare a well-crafted statement, and then respectfully request that the gallery have it available for the public. Most galleries, no matter what their personal preferences, are not likely to turn down professionally developed, intelligent and accessible secondary material.

This is especially true if you tactfully point out all the ways a gallery could use your statement, or better yet, print up a postcard-size "How to Use an Artist Statement" with the following information, then include it in your information packet for potential galleries:

HOW TO USE AN ARTIST STATEMENT
- In press releases
- In show announcements
- As part of a gallery portfolio/exhibition book
- To give to writers/journalists for publicity articles
- As historical notes for a retrospective exhibition
- As a reference to hand to collectors/patrons

No matter how small a detail in the larger scheme of the art world, a skillful artist statement reflects the professional intelligence of its creator. Even the gallery owner, who thought artist statements absolutely insignificant, admitted to me that there was one statement she respected and admired. "It is very intelligent and makes sense. It is to the point..."

"May I have a copy?" I interrupted, hoping to see what single gem, in a field of fakes, had captured her attention. Her answer said it all.

"I don't have any more," she said. "We've handed them all out."

In Case You Were Wondering

Here is one artist statement that hits all the benchmarks.

STORY POTS
by Lydia Grey

Sometimes between waking and sleeping a dream image appears.
Sometimes a powerful feeling rises up and pushes out of me.
Like Persephone, I have been tugged into the emotional underworld.
Like Daphne, I've run from the rational.
Shaping these clay stories lets me honor my deepest feelings.

I want my pots to be touched.
I want their stories to come to life,
to whisper revelations to the hands that hold them.
I make these pots by throwing clay on the wheel, pushing the clay in and out with my fingers, and hand building. I finish them with a thin skin of non-toxic glaze or terra sigillata, some I smoke fire in a pit in my back yard.

If I had lived 5,000 years ago, inbetween gathering food and minding the baby, I would have shaped clay. I can imagine somebody digging up one of my pots in 2,000 years, turning it around in their hands and wondering, who made this? And why?

The End Is Never In Sight

Learning to write an artist statement is a life-long process, which grows and changes alongside your work. When you open up to the vast, vital river of language, your artist statement flows into the totality of your artist story.

Gifted by life and hard work, artists illuminate our world. But if this work is not in the world and of the world, the candle sputters and dies. Paying attention to dynamic details like the artist statement keeps artists, and their art, shining for us all.

For information on consulting and workshops,
email or call Ariane Goodwin, Ed.D.
EM: book@artist-statement.com
PH/FX: (413) 659-3307